50 Cents

T0406034

THE AMAZING MAURICE

THE ART OF THE FILM

THE AMAZING MAURICE: THE ART OF THE FILM

ISBN: 9781803361536

Published by
Titan Books
A division of Titan Publishing Group Ltd
144 Southwark St
London
SE1 0UP

www.titanbooks.com

First edition: December 2022
10 9 8 7 6 5 4 3 2 1

The Amazing Maurice™ is a trademark owned by
Dunmanifestin Ltd.
Images © 2022 Ulysses Filmproduktion and Cantilever
Media.

Did you enjoy this book? We love to hear from our readers.
Please e-mail us at: readerfeedback@titanemail.com
or write to Reader Feedback at the above address.

To receive advance information, news, competitions,
and exclusive offers online, please sign up for the Titan
newsletter on our website: www.titanbooks.com

A CIP catalogue record for this title is available from the
British Library.

Printed and bound in China.

THE AMAZING MAURICE

THE ART OF THE FILM

RAMIN ZAHED

TITAN BOOKS

Contents

Foreword

*T*he *Amazing Maurice* was made by three film producers, Andrew Baker, Robert Chandler and myself (as well as Rob Wilkins from Narrativia, producer for the Pratchett Estate) and, as the producer who initiated the project, I was asked to write a short personal introduction to the art of this 'amazing' film.

The Brothers Grimm wrote a lot of stories in Germany in the 1800s. Fairy Tales. Some of these tales are funny, some are soppy, many are just – in the strict sense of the word – grim. My parents, being influenced by the protest revolutions of 1968, kept me away from the grim German cultural heritage and didn't tell me, for example, about the Pied Piper of Hamelin.

Johann Wolfgang von Goethe and Robert Browning tinkered with the gruesome story, but the tale remained broadly the same for centuries. On the 26th of June 1284, during the pagan midsummer, a multi-colored costumed piper led 130 children out of the town of Hamelin in Germany – never to be seen again. The man with the "magic flute" hadn't been paid by the Mayor for getting rid of a plague of rats, and this was his revenge on the town. According to the Hamelin Museum, this story is known in forty-two countries in thirty languages.

However, the contemporary author who offered a unique insight and gave us a new take on the tale was Terry Pratchett. He wrote a fantastic melange of the fairy tale, adding an amazingly clever tomcat, Maurice, as the main protagonist, surrounded by highly intelligent talking rats, a skinny, gawky piper named Keith, a human story-dynamo and Grim [sic] descendant called Malicia, dangerous crooks and many anxious citizens. He also gave us one of the more terrifying adversaries in modern children's literature in the form of the

"**Terry Pratchett has made the original Hamelin legend popular in far more than forty-two countries and thirty languages.**"

EMELY CHRISTIANS,
PRODUCER

THIS SPREAD Various designs for Keith Candle by Carter Goodrich

Rat King. Terry's special skill was in showing us why the Rat King did what it did.

I was all the more pleased that Narrativia believed in us and gave us, as co-producers, the rights to make this magnificent film out of the novel.

Terry Pratchett has made the original Hamelin legend popular in far more than forty-two countries and thirty languages. Tourists raid the medieval town, which still today looks purpose-built for a fairy tale with all its mysterious heritage-protected wedding-cake houses. And it is wonderful that our movie will carry Terry Pratchett's pied piper story around the world – full of energy, wit, fantasy, unexpected twists and turns, exciting scenes, lovable characters, memorable dialogue, entertaining action and a moral compass!

Everybody who worked on this movie was inspired by Terry Pratchett's sensational book. If he had written it earlier, even my parents would have told me this enlightened story of the Pied Piper of Hamelin – which happened only 199 kilometers north from the place I was born.

Emely Christians

Introduction

When acclaimed British author Terry Pratchett's Carnegie Medal-winning book *The Amazing Maurice and His Educated Rodents* was first published in 2001, critics praised its entertaining plot, memorable characters and the fantasy master's trademark sense of humor and clever world view. As a glowing review of the book in The Guardian put it, "Pratchett bungee-jumps into the midst of grim things, and lifts his hat!"

The beloved author's trademark charm and delightful characters have now come to animated life in a new movie, directed by Toby Genkel and co-directed by Florian Westermann, with a script by Terry Rossio. Featuring a stellar voice cast that includes Hugh Laurie, Emilia Clarke, David Thewlis, Himesh Patel, Gemma Arterton, Ariyon Bakare, Joe Sugg, Julie Atherton, Hugh Bonneville, Peter Serafinowicz, David Tennant, and Rob Brydon, the adaptation is produced by Emely Christians, Andrew Baker, Robert Chandler and Rob Wilkins.

The plot, which has been described as "outrageously cheeky" by critics, is a fresh spin on the tale of the Pied Piper of Hamelin. The central character is, of course, Maurice (voiced perfectly by Laurie) – an ethically challenged ginger cat who uses a group of super-intelligent talking rats and a naïve piper boy called Keith (Patel) to con villagers out of their money. As they often do, things take a surprising turn when they meet a clever, book-loving girl called Malicia (Clarke) who has her own ideas about how this story should turn out.

TOP Concept art for Bad Blintz by Felix Presch

MIDDLE Bad Blintz moods by Heiko Hentschel

RIGHT Bad Blintz houses by Edwin Rhemrev

OPPOSITE Concept art for Bad Blintz by Felix Presch

The tale of how this twenty-eighth book in Pratchett's Discword fantasy series (and the first one written for children) was adapted into a charming feature, co-produced by Sky Cinema, Germany's Ulysses Filmproduktion and the UK's Cantilever Media, with animation studios Studio Rakete and Red Star 3D, has its own twists and turns as well.

Emely Christians, an acclaimed producer with Germany's Ulysses Filmproduktion, whose many credits include *A Stork's Journey*, *Niko & The Way to the Stars*, *Luis and the Aliens* and the two *Ooops! Noah Is Gone* movies, had optioned the rights and developed the script and project, but was looking for partners to jointly realize the production of the property. "We had

started to put our own people on the project and had some terrific production design art created by Heiko Hentschel," Christians recalls. "That was around the time I got to know Andrew Baker and our other producer, Robert Chandler. We wanted to add a team from the UK, because this was a Terry Pratchett adaptation."

Andrew Baker is a lifelong fan of Pratchett's work and has all of the author's books on his mantelpiece. A veteran of ITV Kids and producer of the animated series *Robozuna* and the acclaimed documentary *The United Way*, Baker was looking for an animated feature to develop when he read the script, penned by Terry Rossio, one of the original writers of *Aladdin*

(1992) and *Shrek* (2001), back in 2016. "I read it on a flight from Miami to London and I thought it was absolutely brilliant," says Baker. "There were some differences to the book, but the spirit of the book was in the screenplay. I thought the characters were exactly as Terry Pratchett had written them, so I said yes right away. Robert and I began our conversations with Emely, and we got to know each other as well as Narrativia, the production company that handles the Pratchett estate."

Ulysses and Cantilever wanted a UK partner animation studio and felt it made great sense for Sheffield-based Red Star 3D – who had recently completed their first feature film – to split the work with Studio Rakete in Hamburg.

Chandler, who had worked with the team at Red Star 3D studio on their previous feature, *StarDog and TurboCat*, also fell in love with the script and Pratchett's eccentric and unforgettable characters. "The screenplay was so much fun to read as well," he recalls. "Luckily, the incoming director of Sky Cinema, Sarah Wright, is also a big cat lover. She saw the poster art we had created for the project and could see that our Maurice had bags of character. She read the script and loved it, too. Before long, Sky came on board."

The producer was also in charge of finding the right voice actors for the project. "We were very lucky to have Debbie McWilliams in charge of our casting," Chandler mentions. "She has cast the last fifteen James Bond movies. When Debbie phones you, you take the call! I don't think our partners were expecting to get all the amazing actors who came on board, but I always knew we'd get a good cast. This is a story with such depth and range. Once Hugh Laurie joined and everyone saw the caliber of talent attached, including Rossio's script and Heiko Hentschel's designs, it became easier to attract actors."

Both Chandler and Baker point out that the simple mention of Terry Pratchett's name opened doors for them. "That's how we ended up with our character designer, Carter Goodrich," recalls Baker. "We did some research and decided that we would love him to take an early shot at designing the characters. Of course, we had big ambitions for the way we wanted the movie to look, but we knew we wouldn't have a budget like a Disney feature. We managed to finance the project for about €10.5 million initially, so when we reached out to Carter and to the actors, we told them that we didn't have a lot of money to play with. But as soon as we told them it was a Pratchett project, it began to open doors."

Goodrich says he was immediately intrigued by the story's mixture of a cat, rats, a period costumed pied piper and a smart female protagonist. "The fact that the rats were in their own costumes as well is always a bonus," he adds. "When animals are clothed it allows for more opportunities to find good shapes and clues regarding who the character is or could be.

"I was allowed to simply make a pass on the characters without too much input

as to details," he recalls. "The inspiration comes from how I might see or imagine them; who they might be in addition to their assigned role in the story. If the characters don't come with a whole lot of specific details, then they're usually more fun and easier to explore. When you don't have all the voices in your head, then it's a looser, freer process, so you might be able to bring something to the table that hadn't been considered, which gives the character something unexpected. Not that I necessarily did that with these characters, but I hope I did!"

Producer Rob Wilkins of Pratchett's production company Narrativia, who is also behind the successful adaptations of the author's *Good Omens*, *Troll Bridge* and *The Abominable Snow Baby*, says he knew from the early sketches of the characters that the detail-oriented producers really understood the author's sense of humor. "For me it's a joy to see a faithful adaptation of Terry's work and to know that he would have approved; to see his words treated with such respect was a wonderful experience," notes Wilkins. "And as a cat lover and observer of the human condition I have no doubt that Terry would have approved of our Maurice."

"When animals are clothed it allows for more opportunities to find good shapes and clues regarding who the character is or could be."

CARTER GOODRICH,
CHARACTER DESIGNER

Creative Choices

The film's talented directors, Toby Genkel and Florian Westermann, both realized that *The Amazing Maurice* wasn't going to be your average CG-animated family movie. "My first reaction was one of, 'Oh my god, Terry Pratchett!'" recalls Genkel, an acclaimed veteran of the European animation scene, who has directed movies such as *Little Bird's Big Adventure (A Stork's Journey)*, *Ooops! Noah Is Gone*, *Yakari: A Spectacular Journey* and *Two by Two: Overboard!* "I felt a bit of weight on my shoulders," he recalls. "When I read the book, I knew that there was nobody quite like Pratchett. A fantastic story, all those wacky characters and effortless humor, paired with very strong commentary – it's so impressive how he always manages to reflect the truth about human behavior with such great humor."

Genkel adds, "When you read the books, you immediately feel that they would make great movies. The writing has such great rhythms to it and the imagery is so strong. Apparently, he loved Germany and the Black Forest and the Grimm fairy tales, so it truly resonated with me. I love the way he looks at this familiar story and turns it around."

"I had worked on movies such as *Ooops! Noah Is Gone, Part 2* and *Luis and the Aliens* as art director at Studio Rakete," Westermann says. "I know that a movie like this doesn't just fall into your lap, so I was very pleased that I got the chance to co-direct the movie with Toby, with whom I had worked in other capacities before. After I read the book, I thought it was fantastic. What I really liked was it wasn't going to be a movie for little kids. This was truly a family-targeted movie – a mystery thriller for beginners!

"The film's intriguing storyline and humor speaks to the adults in the audience, while entertaining younger kids at the same time," continues Westermann. "What makes a Pratchett story so strong are the characters. You can't help but love them, even the villains, because they are so vividly imagined. Also, the characters change and don't stay the same from the beginning of the book to the end."

"I was fascinated by the narrative style and the different levels that the film deals with," adds Christians. "Suddenly the protagonists stop and reflect on what they have just experienced. There are characters of different levels and some understand that they live in an 'imaginary' world. Terry Pratchett created an incredible world of characters. Integrating this respectfully into an animated film and giving viewers the chance to get to know everyone was a big challenge – but one we gladly accepted."

OPPOSITE TOP Boss Man posing by Michael Hülse

LEFT & OPPOSITE BOTTOM Boss Man exploration by Heiko Hentschel

> "Terry Pratchett created an incredible world of characters. Integrating this respectfully into an animated film and giving viewers the chance to get to know everyone was a big challenge – but one we gladly accepted."

EMELY CHRISTIANS,
PRODUCER

Creating Visual Catnip

The artistic team working on the feature were all united in the common goal to make the movie as visually arresting as possible, as well as moving away from what is seen as the typical modern CG look for family animated movies. As producer Andrew Baker points out, "We knew that our story is set against a fictional medieval German town, so our artists did a lot of research on actual locations in Germany to get the right look for the buildings, the cobblestone streets, the forest. There are actual buildings in the country that date back to the Middle Ages, so we had all these great real-life references."

The team had a secret weapon in the artwork created by production designer Heiko Hentschel for the movie. "He brought something extra special to the film," says Baker. "The movie's characters have such a distinct look. They are not Disney nor

arthouse. Maurice, Malicia, Keith, all our rats – they look quite unique and show so much personality. We were staying away from anything that looked generic or bland."

"We were aiming very high, [for] something that could rival a big CG-animated feature from Pixar or Disney," explains Hentschel. "I always aim for visual simplicity in my designs. We opted for simple, recognizable shapes for the characters, which stands in good contrast with the elaborate sets. The main goal is to deliver a quick read. The audience should instantly get what the image is trying to convey.

"When I create color or mood boards, I think of big broad shapes and brush strokes," Hentschel elaborates. "Unless it's super close-ups, I discard finer details like eyes, noses, mouths and the like. This saves a lot of time and keeps the creative energy high. On top of that, nobody argues about facial

expressions and eye directions. For me, it's all about light, color and focus. The big picture, so to speak."

The artist wants the movie's characters and designs to stay with the audience for a long time. "I hope they'll trust these characters and tag along on their adventures," he adds. "Design is only one of the storytelling elements. The story should be king, and the personality of these amazing characters should rule and guide us through their worlds."

BELOW LEFT Mood sketch by Heiko Hentschel

BELOW In and around Bad Blintz 3D artwork by Red Star

OPPOSITE Inner walls of Bad Blintz by Felix Presch

"Our story is set against a fictional medieval German town, so our artists did a lot of research on actual locations in Germany to get the right look for the buildings, the cobblestone streets, the forest."

ANDREW BAKER,
PRODUCER

Layouts, Lights & Effects

The teams of seasoned experts in Germany and the UK worked closely for many months and lent their expertise in previz layout, environments, lighting and effects to the visually sophisticated world of *The Amazing Maurice*.

"The first thing we had to understand was what kind of look we were after," notes the film's environment supervisor Haris Ahmad. "Were we going for something that was super fantastic, realistic or somewhere in between? Then we had to reverse engineer it to get the best results. For this movie, the shape languages were heavily stylized, but when it came to textures and surfaces, the directors and producers were after a realistic look and something that was slightly exaggerated in terms of scale. We were actually able to draw inspiration from some of our favorite stop-motion movies from Aardman Animations and Laika Studios."

"It was quite challenging both technically and artistically to create the environments for the town of Bad Blintz," says Ahmad. "The directors wanted a very tactile feeling, and the usual technical way to build the cobblestones wasn't the most efficient. So we divided the town into sixteen separate areas and created millions of cobblestones of different shapes and sizes. We also had to make sure they were all animation-friendly, since we have all these rats and humans running around these roads. The contact points had to be clean. Everything had to be well balanced and computable as well."

Previz layout supervisor Faraz Hameed, whose credits include blockbusters such as *No Time to Die*, *The Dark Knight* and *Doctor Strange* says his team wanted to bring a unique feel to the movie. "We didn't want every scene to be a joke or a gag. It's important to zero in on the focus of every scene – is it about Maurice or the rats or the humans? It's all about achieving the right balance. You want each one of the characters to get their fair share."

For Hameed, the grand finale of the movie was one of the most challenging to get right. "We wanted the stand-off between Boss Man and the rats to be exciting and action-packed. We especially didn't want it to be too scary. So we tried many different approaches and ideas. We played in the sandbox so that we could keep the audience on the edge of their seats."

The film's finale also had its share of challenges for visual effects supervisor André Correia. "We had to figure out how to depict the magic required in

ABOVE Bad Blintz cobbled streets 3D environment artwork by Red Star

LEFT Cobblestones with manhole cover by Felix Presch

OPPOSITE TOP Battle of the minds early concept by Heiko Hentschel

the final confrontation. Boss Man creates this force field and Maurice and the rats are frozen in space, so we had a good amount of discussion about how to make it more believable – whether to use mist, smoke, water, cold or dry ice as visual references. We also had to visualize the final disintegration of Boss Man and the emergence of the Rat King, which also required a lot of experimentation and tinkering."

CG and lighting supervisor Nico Rehberg points out that he and his team were able to create a mix of natural and artificial light for the movie. He also cites the film's showdown between the rats and the Rat King as one of his most complex assignments. "It was very complicated in terms of lighting. We didn't want the Rat King to look too disgusting, because, after all, he's made of lots of rat tails that are knotted together. The lighting in that scene had to make it all look plausible. We started out with a mountain of rats with lots of red tails sticking out. We did a lot of fine-tuning and lots of back and forth with the art director to get everything balanced and to achieve the desired mood."

Character effects supervisor Jared Embley (*Game of Thrones*, *Pokémon Detective Pikachu*) points out

that working with CG-animated hair has its share of difficulties. "We were lucky because our rats' fur was pretty short and we didn't have to worry about the fur interacting with other objects. However, we had to simulate Maurice's hair blowing in the wind in the final sequence. Overall, it has been quite an amazing experience to create this distinctive look for the world of Terry Pratchett. We have had the opportunity to deal with very cartoony squash-and-stretch characters, which is quite different from working in visual effects in live-action movies. It opened up a whole new world for me."

"What's great about Pratchett is that there are no easy lessons and no straightforward good versus evil characters," adds Hameed. "There's quite a spectrum, so you don't really know who's quite good or bad. Is Maurice a bad guy? What about the rats? They are all struggling to survive. That's what makes our movie quite different from many of the other animated movies we have all seen."

"The film's strength lies in entertaining on

different levels. If it is quiet for the rats in one place, an adventure begins on the human side," concludes Christians. "I really hope that the audience will feel entertained; all viewers will find their favorite characters and hope and cheer for them. The narrative delves deeply into the experiences of the characters, especially Maurice. In the course of the story, he learns that it is worth standing up for others and that having a conscience is good. The fact that this message is so playfully integrated makes the movie quite special."

CHAPTER ONE

You've got Rats!

Maurice

"They said he was amazing. He'd never meant to be amazing. It had just happened!" That's how Terry Pratchett describes the feline hero of his story. Of course, being so clever and cunning and "interesting," he is the main plot engine of the movie as well. In the script, he is described as "a sentient cat" that is "ginger and regal, very furry, with a tail nearly as big as his body, a cat among cats. He likes to call himself 'Maureece,' but his name is really pronounced 'Morris!' He moves like a feline Fred Astaire!"

This was a perfect assignment for character designer Carter Goodrich, who says he always enjoys drawing cats. "As far as I'm concerned, cats are most fun to draw when they have some bulk in shape. Lots of thick fur or actual body mass. So that's how I did him!"

PREVIOUS SPREAD Mood sketch by Heiko Hentschel, based on storyboard art by Jo Bub

BELOW & RIGHT Maurice by Heidi Smith

As the film's character supervisor Sophie Vickers explains, "He is a quadruped who loves swishing his elegant tail around, but sometimes he stands on his hind legs and articulates like a human. That was a bit of a challenge for us, because real cats don't stand upright, and Maurice bridges the animal and human worlds. We wanted him to be appealing and tactile, a character you would want to stroke and cuddle, although he's overweight, quite greedy and has a mouth that can look slightly creepy. We worked very hard on his fur to make sure it looks touchable and realistic."

Animation supervisor Peter Bohl points out, "Hugh Laurie brought

"**Sometimes he stands on his hind legs and articulates like a human. That was a bit of a challenge for us, because real cats don't stand upright...**"

SOPHIE VICKERS,
CHARACTER SUPERVISOR

LEFT Maurice by Carter Goodrich & Oliver Kurth, color by Oliver Kurth

TOP Maurice by Carter Goodrich

ABOVE Maurice by Oliver Kurth

so much to this character. When you have these amazing voices reading the lines, a good animator can immediately see what they can do. The sarcastic tone he added to the readings really made it fun to animate.

"I used to have a big fat red cat at home, who looked just like Maurice, so I didn't have to look at other cats," Bohl adds. "I have an example sitting in front of me today, too! We also had a great library of animations and live-action footage of cats to make sure we captured the way he runs and jumps and moves accurately."

Animation director at Red Star 3D Jerome Boutroux says Maurice was one of the tougher characters to animate. "He is gesturing a lot and sometimes he walks on his hind legs, and we weren't doing a super cartoony world. His emotional arc is that, in the beginning of the movie, he's pretty

much a cat – he doesn't care about anyone else and he's looking after himself and thinking about his next meal. In short, we kind of like him, but dislike his choices. We had to play that fine balance of making the audience like him, while showing his true character. But then he proves to be different and shows his love for the other characters in the third act."

Producer Robert Chandler says, "On one level, Maurice is like a bandit who discovers gold in a 1950s western and doesn't tell others about the treasure and disappears. But as he goes deeper into the adventure, he develops a moral conscience and he returns to help the rats. He is self-centered, smug and arrogant, and Hugh Laurie plays him brilliantly. It's a great moment of storytelling when he is finally willing to sacrifice something precious to him when the crunch time arrives."

TOP & RIGHT Maurice posing by Michael Hülse

ABOVE & RIGHT Expression sheet for Maurice by Michael Hülse

THIS PAGE (COLOR)
Maurice by Heiko Hentschel, based on designs by Carter Goodrich

Keith Candle

The first version of the Pied Piper of Hamelin we meet in the movie is Keith Candle, a hapless, dreamy-eyed teenager who is a talented flute player, but who walks through life not quite knowing what his next day is going to look like. Of course, he is easily manipulated by Maurice and bewildered by everything that happens around him. He may not realize it, but he is also madly in love with Malicia.

As director Florian Westermann sees it, Keith was picked by Maurice for the scam because he is easy to command and manipulate. "He is happiest when he plays the flute and when he's not playing, he kind of drifts away," he says. "He doesn't really care about the discussions between Maurice and the rats. Then things change when he meets Malicia. Here is someone who challenges him in a good way. He understands what he has to do. She helps him stand for something and stop being a slacker, so he finally takes the steps he needs to take to become a real protagonist. I think Himesh Patel did a fantastic job of giving voice to this character."

Animation supervisor Peter Bohl adds, "Keith is a very lovely character who is very constrained in comparison with the other characters. He doesn't have very big movements and is more subtle, mostly due to his fears. With him, we had to focus the acting on his face – small glances, simple gestures and tiny movements of the mouth."

RIGHT Keith by Heidi Smith

RIGHT (LEFT TO RIGHT) Keith by Carter Goodrich; Heiko Hentschel; color sketch by Heiko Hentschel

Producer Robert Chandler says he found the romance between Keith and Malicia quite moving and effective. "Their finding romance in the midst of this big drama is quite poignant. There's a scene in the movie that brings tears to my eyes, and it involves the two of them. It's a detail that wasn't in the original script and one of the animators added it because it felt right for the characters. Something big and threatening is happening, and Malicia simply puts her arm in front of Keith to protect him. It honestly made me weep when I saw it. I love details like that, which the audience might miss at first, but when you actually notice them, it enriches the whole experience!"

TOP LEFT, LEFT & CENTER Keith by Carter Goodrich

FAR LEFT & RIGHT Keith by Heiko Hentschel

For producer Andrew Baker, one of the funniest scenes in the movie also involves both Keith and Malicia. "The two of them are tied up in the cellar together and she asks him, 'Are you sure you don't have a superpower... or matches... or a knife?' He replies, 'No, I don't!' and then, immediately, a sausage whacks him on the head with great comic timing. It's a moment between these two characters when we realize he's just an ordinary kid, despite what Malicia might be looking for."

LEFT & RIGHT
Concept expression sheet for Keith by Michael Hülse

LEFT Keith by Heiko Hentschel

RIGHT Keith posing by Michael Hülse

KEITH'S PIPE & BAG

THIS BOX Concept art for prop development by Heiko Hentschel, modeling by Red Star

LEFT Keith playing the pipe by Michael Hülse

Main Clan Rats

Ever since the early days of *Steamboat Willie* in 1928, rodents have been hugely popular and key players in the world of animation. Not surprisingly, *The Amazing Maurice* introduces filmgoers to a remarkable collection of rats, which are recruited to help our cunning cat in his money-making schemes.

The designers of the movie's five main rats were tasked with developing five distinct looks for the leads. As character supervisor Sophie Vickers notes, "We didn't want to go near previous rat characters that were popular in other CG-animated movies. Yet, when you are creating a bipedal rat with fur,

BELOW Main rats
by Heiko Hentschel

there will always be similarities. The trick with rats is to balance the appeal with the fact that they are actually rats, which are not animals that are often adored. With Maurice, for example, there's an appeal that comes naturally with cat characters. In reality, rats are quite simple. They have a very subtle kind of skin, and we didn't want any grossness about them. In fact, in one of our early development concepts, we had included too many life-like details and they looked icky! In contrast, the final versions are quite big-eyed and as cute as possible!"

"The trick with rats is to balance the appeal with the fact that they are actually rats."

SOPHIE VICKERS,
CHARACTER SUPERVISOR

BELOW Main rats posing
by Michael Hülse

Darktan

Darktan is a large, brawny rat, whom co-director Florian Westermann describes as a "marine soldier type." In the book, he is described as the leader of the Trap Disposal Squad and well-respected for his knowledge of disarming traps to keep them all alive. As the names of the clan rats are generally taken from the rubbish they found on the dump where they were living when they developed super-intelligence, Darktan's name comes from shoe polish, but also references the character D'Artagnan (from *The Three Musketeers* novel), who similarly sported a belt and sword.

Carter Goodrich's original designs for the character truly captured the spirit of this rough-and-tumble rodent, so very few tweaks were required in development. "This male rat was described as a dangerous type, so it goes without saying that it was fun to design him," Goodrich says. "I liked the idea of giving him this Bill Sykes [the heavy-set villain from *Oliver Twist*], London gutter look."

ABOVE & BELOW Darktan by Heidi Smith

"Carter Goodrich's designs pretty much nailed Darktan's character right away."

HEIKO HENTSCHEL,
PRODUCTION DESIGNER

ABOVE & FAR RIGHT Darktan by Carter Goodrich & Oliver Kurth

RIGHT & CENTER Darktan by Carter Goodrich

TOP RIGHT Darktan by Carter Goodrich, color by Oliver Kurth

"Carter Goodrich's designs pretty much nailed Darktan's character right away," production designer Heiko Hentschel recalls. "The main question for us was whether we should go for fully clothed rodents or opt for a more minimalistic, functional look. Ultimately, we decided to go with a practical approach, so the rats would only 'wear' items they need for their jobs within the clan. That's why Darktan is always packing belts, nails and hooks. He always has what he needs to disarm a rat trap."

LEFT Model sheet and details for Darktan by Gerlinde Godelmann

LEFT & BELOW Darktan by Heiko Hentschel

LEFT, FAR LEFT & BELOW
Expressions and posing for
Darktan by Michael Hülse

BELOW Belt and ropes by
Heiko Hentschel

Dangerous Beans

Dangerous Beans is described as an albino rat who is the spiritual leader of the Clan, as they refer to themselves, after they developed super-intelligence upon eating rubbish from the Discworld's school of wizardry, Unseen University. He is also the interpreter of the utopian *Mr Bunnsy* book. As production designer Heiko Hentschel explains, "He is such an important, complex character that I didn't know how to start. In the novel he was described as smaller than all other rats, so we tried that, but we didn't want him to look frail. When I heard that the Scottish actor David Tennant voiced him in an audio adaptation for BBC Radio, I found the inspiration that I was looking for. We were all so excited when we heard that he would also lend his voice to our version of Dangerous Beans."

ABOVE Dangerous Beans by Heidi Smith

ABOVE Expression sheet for Dangerous Beans by Michael Hülse

Animation director Jerome Boutroux describes Dangerous Beans as a visionary priest who has helped the Clan since they all became cognizant beings. "Pratchett draws a parallel between them and the evolution of human society," he notes. "He is explaining how the rats came to terms with how they went from wild, primal animals to becoming a family that takes care of each other with a sense of responsibility. It's interesting to point out that David Tennant's father was a priest, so the actor has lent to his voice the way a clergyman talks to his flock with eloquence and caring that comes through."

TOP LEFT & RIGHT Dangerous Beans by Heiko Hentschel

ABOVE Model sheet and details for Dangerous Beans by Gerlinde Godelmann

BELOW Posing sheet for Dangerous Beans by Michael Hülse

RIGHT Dangerous Beans by Michael Hülse

"David Tennant's father was a priest, so the actor has lent to his voice the way a clergyman talks to his flock."

JEROME BOUTROUX,
ANIMATION DIRECTOR

LEFT Dangerous Beans by Heiko Hentschel

BELOW Dangerous Beans before the transformation by Heiko Hentschel

Peaches

The kind, smaller female rat is a sympathetic creature who is known for her scarf and her unwavering belief in the heavenly promises of the rat bible, aka the *Mr Bunnsy* book. The film's original character designer Carter Goodrich says, "Peaches has a more wholesome, innocent look, so her flower print stitched homemade-looking sack/dress and scarf were lots of fun to come up with."

"Most of her design came from Carter Goodrich," production designer Heiko Hentschel confirms. "Once I found out that there are real rats out there in the natural world that have a wonderful golden peach-like fur color, I was in love. This may sound corny, but character color is very important to me. Color can speak volumes even before a character opens their mouth. Peaches is pure warmth to me!"

ABOVE Peaches by Carter Goodrich & Oliver Kurth

ABOVE RIGHT Peaches by Carter Goodrich

ABOVE & MIDDLE RIGHT
Peaches by Heidi Smith

"This may sound corny, but character color is very important to me. Color can speak volumes even before a character opens their mouth. Peaches is pure warmth to me!"

HEIKO HENTSCHEL,
PRODUCTION DESIGNER

"Peaches is an eager yet thinking disciple who hangs on Dangerous Beans' every word," says animation director Jerome Boutroux. "She realizes that a cat could eat the rats, so she always watches her back when Maurice is around. She knows there's something about him that is not quite trustworthy. In turn, she is always pushing his buttons and likes to call him 'Morris' instead of his preferred 'Maureece'."

ABOVE Concept art for Peaches by Oliver Kurth

BELOW Peaches by Carter Goodrich & Oliver Kurth

RIGHT Concept art for Peaches by Carter Goodrich & Oliver Kurth, color by Oliver Kurth

BELOW Peaches posing by Michael Hülse

"Peaches is an eager yet thinking disciple who hangs on Dangerous Beans' every word."

JEROME BOUTROUX,
ANIMATION DIRECTOR

LEFT & ABOVE Peaches by Heiko Hentschel

RIGHT Peaches before the transformation by Heiko Hentschel

LEFT Peaches by Heiko Hentschel

TOP Model sheet and details for Peaches by Gerlinde Godelmann

ABOVE Expression sheet for Peaches by Michael Hülse

Nourishing

The rat team's other female rat had to look and feel different from the older, more maternal Peaches. In the script, she is described as "punky and adorable." According to production designer Heiko Hentschel, the team enjoyed creating this key part of the movie's main rodent quintet. "The first briefing described her as a flower-girl character, but I felt that we needed more contrast between her and Peaches," he explains. "So I suggested a more daring pirate-like characteristic, with piercings and a little leather vest – something I would have imagined for the book's original character Hamnpork. I am glad the directors and producers liked this idea." Producer Robert Chandler adds, "I love Nourishing's punky naivete. Punk is about asking awkward, sometimes naïve, questions, and Nourishing does that frequently. It's good to have characters who ask awkward questions."

ABOVE & OPPOSITE BOTTOM Nourishing by Heiko Hentschel

LEFT & BELOW Nourishing by Heidi Smith

"I suggested a more daring pirate-like characteristic, with piercings and a little leather vest."

HEIKO HENTSCHEL, PRODUCTION DESIGNER

ABOVE Nourishing by Michael Hülse

ABOVE Nourishing with separate waistcoat and earrings by Heiko Hentschel

Sardines

The most theatrical and elegant rat of the group, Sardines has a special fondness for tap dancing. At some point, he even asks his friends, "Why do we wear clothes? It makes no sense... unless we're on stage!" His innate dancing talents make him quite a natural for Maurice's Pied Piper scheme.

According to production designer Heiko Hentschel, the team often thought about Fred Astaire or Frank Sinatra as they worked on designing and animating this unforgettable black-and-white rodent. "I especially like all the little details," he recalls. "His fur resembles a little elegant jacket; his eyelids are a bit darker, as if he has danced the whole night through. He also has something I call 'red wine lips,' suggesting that he likes to have his share of red wine when nobody is watching. I believe his bright blue eyes were inspired by 'Ol' Blue Eyes' [Sinatra] himself."

LEFT & BELOW Sardines by Heidi Smith

"I believe his bright blue eyes were inspired by 'Ol' Blue Eyes' [Sinatra] himself."

HEIKO HENTSCHEL,
PRODUCTION DESIGNER

ABOVE, RIGHT & BELOW Sardines by Heiko Hentschel

FAR RIGHT Sardines with separate hat, bow, cufflinks and cane by Heiko Hentschel

Rustic Village

The movie opens in a rustic medieval village in Germany – a country strongly associated with many familiar fairy tales and legends, including the tale of the Pied Piper of Hamelin (a real town in Germany). The village is imagined to be in a flat landscape in the northern regions of the country. These flatlands stand in contrast with the movie's major backdrop, the town of Bad Blintz, which is on top of a hill. Similarly, the pastoral and brightly-colored opening number, which features Maurice and the rats delivering their song-and-dance routine, stands in sharp contrast with the later scenes in the movie when we enter the Bad Blintz sewers and Ratcatchers' Guild.

Producer Andrew Baker explains, "We were very fortunate, because this book is also part of Terry Pratchett's Discworld universe, which he describes as a round, flat world, on the backs of four elephants on a turtle, spinning in space. Many of his books have crossover characters, but what was special about *Maurice* was that it's self-contained and it's

BELOW Concept art detail for rustic village by Tom Olieslagers

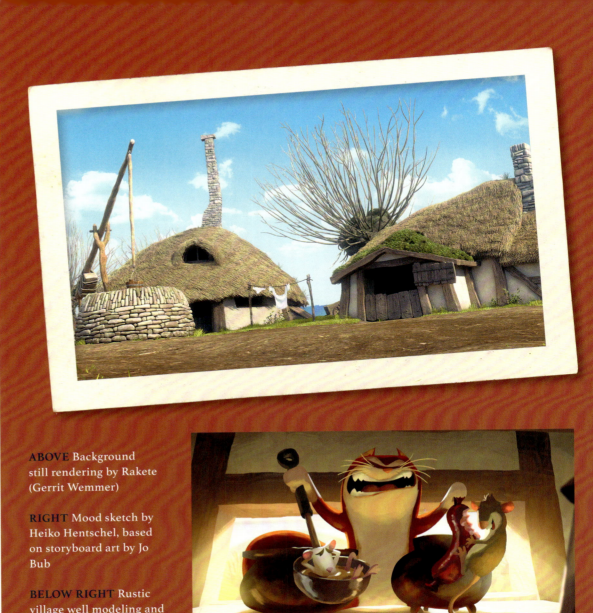

ABOVE Background still rendering by Rakete (Gerrit Wemmer)

RIGHT Mood sketch by Heiko Hentschel, based on storyboard art by Jo Bub

BELOW RIGHT Rustic village well modeling and shading by Red Star

OPPOSITE TOP Rustic village by Tom Olieslagers

OPPOSITE MIDDLE & BOTTOM Rustic village by Tom Olieslagers, color by Heiko Hentschel

set in a medieval mid-European part of the world. It's the kind of location where you have forests, mountains, big castles on hills and little villages – which can have rat problems!"

"Nothing in the village or the town is super straight," says director Florian Westermann. "We wanted the world to belong to the sixteenth or seventeenth century. But on the other hand, we didn't want it to look dirty and unwashed, with all the humans having black teeth. We still wanted this world to be appealing and for the audience to feel like they could just reach out and take a walk along the country roads."

BELOW Rustic village overview by Tom Olieslagers

RIGHT Mood sketches by Heiko Hentschel, based on storyboard art by Jo Bub

BELOW Rustic village by Tom Olieslagers

ABOVE & TOP Rustic village creek by Tom Olieslagers

Rustic Villagers

What would a tale about the Pied Piper of Hamelin be without a collection of "Rustic Villagers?" For Maurice's opening number, the creative team were aiming to deliver an eccentric cast of medieval villagers that would look at home in this fairy tale environment – never overshadowing the main stars, but looking as if they all belonged to this off-the-wall backdrop imagined by Terry Pratchett.

According to director Florian Westermann, a special effort was made to distinguish the villagers from the city dwellers. "Our villagers had to be very simple people, dressed in drab, simple clothes. They had to look as if they were in black-and-white against the colorful backgrounds. Although they were created as background, sideline characters, we

still wanted them to be an eclectic group, different in size and shape, and quite original-looking and fun to observe."

Production designer Heiko Hentschel mentions that special attention was paid so that the villagers offered a nice multicultural mix. "I took all the things that I love and threw it in this rustic community," he says. "A wonderfully wrinkled Sicilian granny, an English housewife, a candlestick maker of Indian descent, etc. – we had a cast from all over the world to set the tone for our movie in the best possible way."

BELOW Chicken by Heiko Hentschel, color by Michael Hülse

BELOW Rustic horse by Heiko Hentschel, color by Michael Hülse

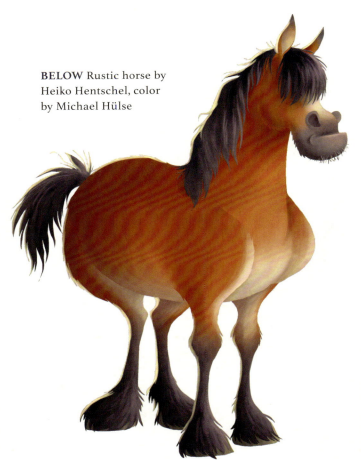

BELOW Mood sketch by Heiko Hentschel, based on storyboard art by Jo Bub

BOTTOM RIGHT Bucket, 3D render by Red Star

RIGHT & FAR RIGHT
Rustic baker posing by
Michael Hülse

"I took all the things that I love and threw it in this rustic community. A wonderfully wrinkled Sicilian granny, an English housewife, a candlestick maker of Indian descent, etc..."

HEIKO HENTSCHEL,
PRODUCTION DESIGNER

LEFT & FAR LEFT Rustic
candlestick maker posing by
Michael Hülse

RIGHT Rustic candlestick
maker by Heiko Hentschel

RIGHT Rustic baker posing by Michael Hülse

BELOW & OPPOSITE BOTTOM Rustic villagers color lineup by Heiko Hentschel

ABOVE Expression sheet for rustic candlestick maker by Michael Hülse

ABOVE Rustic villagers character lineup by Heiko Hentschel

"Our villagers had to be very simple people, dressed in drab, simple clothes. They had to look as if they were in black-and-white against the colorful backgrounds."

FLORIAN WESTERMANN,
DIRECTOR

CHAPTER TWO

Foreshadowing

Billy Spears & Ron Blunkett

The film's two bumbling ratcatchers, voiced by the film's directors, henchmen to the grand villain, Boss Man, had to look quite cartoony and very different from each other to make the most of their screen time. They are two unpleasant characters who found themselves in way over their heads when their little money-making scheme went awry following the accidental creation of the fearsome Rat King.

"Since we don't have much time to introduce them in the movie, we needed to make a strong design statement right from the start," explains production designer Heiko Hentschel. "I turned Ron into a walking cannonball with a large hat and Billy became a sinister, statue-like character. Most of their expressions were inspired by Chuck Jones cartoons, because I love how a funny face can turn into an evil smile. That's what I was thinking when I was drawing both: 'Make them evil. And ugly – really ugly!'"

PREVIOUS SPREAD
Mood sketch by Heiko Hentschel, based on storyboard art by Jo Bub

BELOW Pole with traps by Heiko Hentschel

RIGHT Knives by Gerlinde Godelmann

OPPOSITE BOTTOM LEFT Expression and posing for Billy by Michael Hülse

OPPOSITE BOTTOM RIGHT Early Billy and Ron by Heiko Hentschel

BILLY & RON'S KNIVES

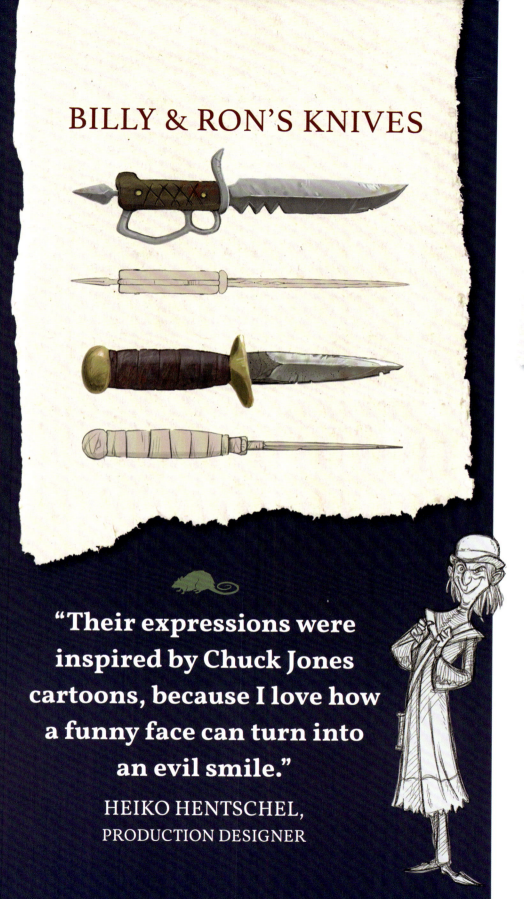

> "Their expressions were inspired by Chuck Jones cartoons, because I love how a funny face can turn into an evil smile."

HEIKO HENTSCHEL,
PRODUCTION DESIGNER

The Mayor

There were several ideas floating around about what the Mayor of Bad Blintz should look like. Initially, the plan was to make him super skinny with hanging, saggy clothes. After all, small German towns were no stranger to famines and food shortages. But then production designer Heiko Hentschel came across some period paintings of German councilors of the era and he realized that they often looked like eccentric men who seemed to have larger-than-life personalities and enjoyed wearing colorful costumes.

LEFT, BELOW & RIGHT Early Mayors by Heiko Hentschel

ABOVE Mayor painting by Heiko Hentschel, 3D artwork by Red Star

LEFT Ancestor painting by Heiko Hentschel, 3D artwork by Red Star

EASTER EGG

The Mayor's chain of office, which he wears around his neck, has various designs on the coins, which were all inspired by Pratchett's novels.

ABOVE Chain of office by Gerlinde Godelmann

Boss Man

Boss Man is always lurking in the shadows. He wears gloves, a low hat and a scarf and, as the screenplay notes, we "don't see any skin at all – like the Invisible Man." As the villain in the book, he is able to get inside the rats' heads. In fact, in the book, he is the voice inside their heads! As co-director Florian Westermann explains, "We needed to come up with a way to show and animate him in the movie. Our screenwriter, Terry Rossio, made the decision to give the Rat King a mysterious physical presence, this disguise made of a pile of rats in a trench coat. It was a very smart decision, because it works better for the audience. A voice in people's heads would be too scary and too abstract for younger kids to understand."

From the very moment actor David Thewlis said his character's first line, Westermann and the team knew that this was a match made in animation heaven. "David just knew what to do with this character," says Westermann. "He was so easy to direct and immediately knew what we wanted. He enjoyed himself as this villain, and when he disintegrates in the end, the audience kind of feels sorry for him. We understand why he's angry about how rats are treated."

"In the book he is more of a psychic malevolent presence," explains character supervisor Sophie Vickers. "But we had to redesign him for the movie, because he was too much of an abstract notion. In the movie, he is a pile of rats thrown together in a trench coat, which appears to be a physical manifestation of the evil character in the book [called 'Spider']. He is meant to be gross and creepy."

Animation director Jerome Boutroux recalls that creating this evil character was one of the most enjoyable parts of the project. "This was something that we really had never done before," he says. "How do we create a body made of rats that wasn't too disgusting? How do we visualize his progression as he loses control? This is a family movie, after all, so we also needed to have moments of humor to lighten the darker parts. References that helped us were the Jack Sparrow character in the *Pirates of the Caribbean* movies, as well as Simon Pegg in *Spaced*. All these slightly off-kilter characters inspired us to visualize a character who has a hard time staying balanced, because the rats are controlling his body."

RIGHT Boss Man posing by Michael Hülse

ABOVE Boss Man by Heiko Hentschel

BELOW Meeting the Boss Man, early concept by Heiko Hentschel

ABOVE Boss Man exploration by Heiko Hentschel

RIGHT Boss Man posing by Heiko Hentschel

Bad Blintz Townspeople

ABOVE & LEFT Vendors shop, posing by Michael Hülse, shutters by Heiko Hentschel

RIGHT Bad Blintz vendor (dark version) by Heiko Hentschel

ABOVE Expressions for Bad Blintz vendor by Michael Hülse

LEFT Bad Blintz vendor by Heiko Hentschel

THIS PAGE Bad Blintz girls and boys, model sheet and details by Gerlinde Godelmann, color by Heiko Hentschel

LEFT Bad Blintz cook by Heiko Hentschel

BELOW & OPPOSITE Various Bad Blintz characters, color lineup by Heiko Hentschel

The Rest of the Rat Pack

In addition to the five major rat stars, the movie also features eight other key rodents who provide additional support whenever the story requires them to do so. Production designer Heiko Hentschel and his team created a set of different rats and presented them to the film's directors and producers. Each one of the support rats was created to have a specific personality and role in the Clan. As the production designer explains, "InBrine became a supervisor for younger rat children. Sell-By was some kind of warrior, while Farmhouse acted as a messenger. Big Savings is a free climber, and Best Before became the scout of the group. Special Offer was designed to be a nervous wreck. Donut Enter was a natural sailor at heart. Last but not least, our sweet Delicious was just that – absolutely delicious!"

LEFT 3D artwork by Elliot Renet & Alice Deverchère

RIGHT 3D artwork by Alicia Sabot & Alice Deverchère

BELOW InBrine before the transformation by Gerlinde Godelmann

"Each one of the support rats
was created to have a specific personality
and role in the Clan."

HEIKO HENTSCHEL,
PRODUCTION DESIGNER

RIGHT (LEFT TO RIGHT) InBrine, Delicious and Special Offer by Heiko Hentschel & Gerlinde Godelmann

THIS SPREAD The Rat Pack, color lineup by Heiko Hentschel

Malicia's Room

Since Malicia is an avid reader, her bedroom is packed with books of all shapes and sizes. Besides a few knick-knacks, a blue butterfly preserved in a glass dome, a wash basin and a mirror, the room is full of books, rolled up maps and illustrations. There is plenty of light coming through the windows of this bright and cheerful room, which also reflects Malicia's general mood and presence. We can just imagine that her favorite piece of furniture is the comfortable magenta reading chair with golden-orange bats floating all over it.

BELOW Mood sketch by Heiko Hentschel, based on storyboard art by Jo Bub

ABOVE Mayor's house by Heiko Hentschel

TOP RIGHT & BOTTOM RIGHT Malicia's room by Edwin Rhemrev

BELOW Malicia's room by Heiko Hentschel, based on a sketch by Edwin Rhemrev

EASTER EGG

If you look carefully around Malicia's bedroom, you will find a bronze chest with lots of feet, a reference to the Luggage that appears in several Discworld books.

The book on the stand is *Twurps Peerage*, Pratchett's homage to the catalog of English nobility, *Burke's Peerage*, and social directory of Ankh-Morpork, the largest city in the Discworld.

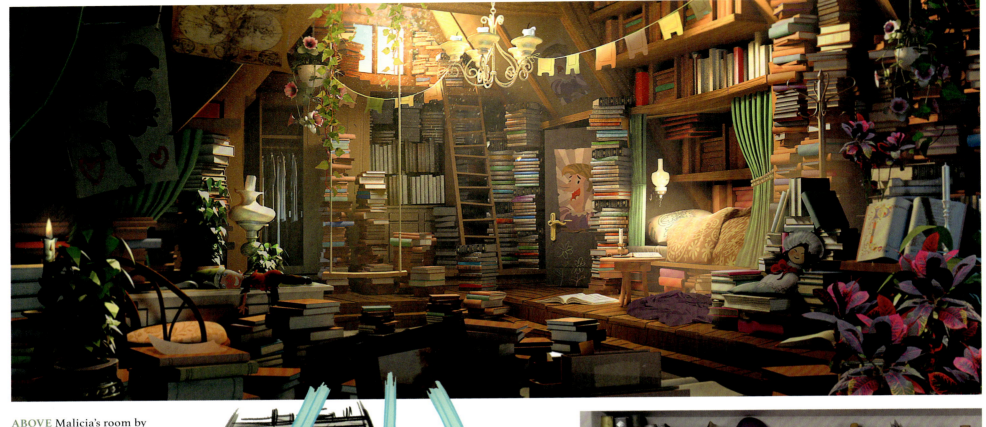

ABOVE Malicia's room by
Edwin Rhemrev

RIGHT Malicia's room by
Heiko Hentschel, based on
a sketch by Edwin Rhemrev

**RIGHT & OPPOSITE TOP
RIGHT** 3D artwork for
Malicia's room by Red Star

ABOVE Bsckground still renderings by Rakete (Gerrit Wemmer)

LEFT Prop modeling by Red Star

FAR LEFT The Luggage replica by Tom Olieslagers, inspired by Paul Kidby

RIGHT Malicia's armchair by Heiko Hentschel, based on storyboard art by Jo Bub

The Mayor's Office

The Mayor's office features a beautiful Terry Pratchett bust on a plinth, which is based on a real one sculpted by Pratchett illustrator Paul Kidby in 2017, two years after the author's death. "I think it is a lovely tribute to Terry," Kidby says of the movie version. "The oil-based clay piece took me three months to create. I initially worked from reference photographs to establish accurate proportions of the facial features. To capture his expression I then sculpted from my memories of our time spent working together. Once I was happy with my three-dimensional portrait, I then made his trademark hat and glasses, both of which are removable. The sculpt, known as a pattern, was then cast in bronze using the lost-wax process in a limited edition of twelve. On the back of the plinth is the Pratchett family motto, *Noli Timere Messorem*, which translated from the Latin means 'Fear Not The Reaper.'"

TOP Background still rendering by Rakete (Gerrit Wemmer)

LEFT 3D environment artwork for the Mayor's office by Red Star artists

RIGHT Terry Pratchett bust, original sculpture by Paul Kidby, 3D artwork by Red Star

EASTER EGG

Look for a poster of Great A'Tuin – the giant turtle on whose back the Discworld is carried through space – on the wall.

RIGHT 3D environment artwork for the Mayor's office by Red Star

MIDDLE RIGHT Great A'Tuin map by Heiko Hentschel

Market & Bakery

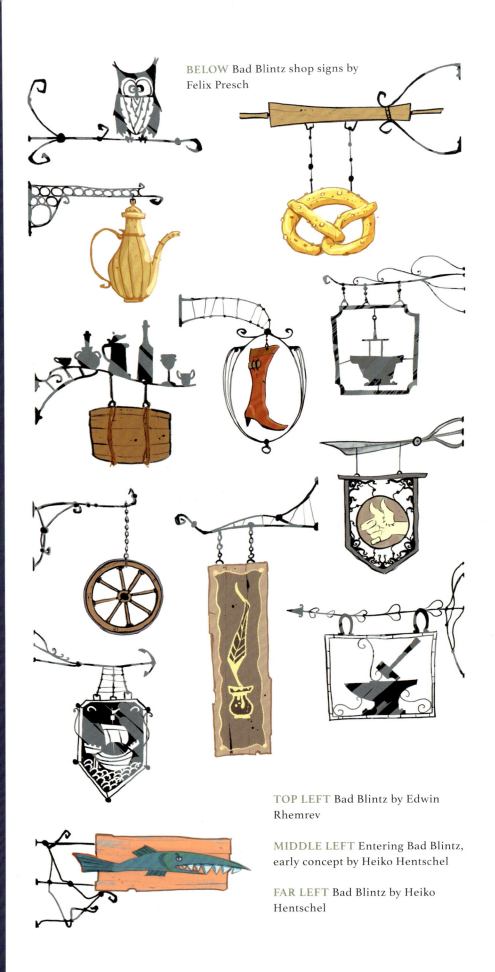

BELOW Bad Blintz shop signs by Felix Presch

TOP LEFT Bad Blintz by Edwin Rhemrev

MIDDLE LEFT Entering Bad Blintz, early concept by Heiko Hentschel

FAR LEFT Bad Blintz by Heiko Hentschel

LEFT Bad Blintz bakery, design and final line by Felix Presch

FAR LEFT Loaf of bread by Heiko Hentschel

BELOW Bad Blintz baker by Heiko Hentschel

ABOVE 3D environment artwork of baker's oven by Red Star artists

RIGHT Mood sketches by Heiko Hentschel, based on storyboard art by Jo Bub

Sewers & Rat Tunnels

In a movie featuring so many rat characters, it's inevitable that a lot of time will be spent diving deep into the underbelly of the town, inside the sewers and along the dark and unpleasant rat tunnels. "The sewers and rat tunnels provided us with a great opportunity to create some fantastic environments," says environment supervisor Haris Ahmad. "The dirtier and more disgusting we made them, the more our directors liked it. They were a lot of fun to create, and when the lighting and compositing departments were done with them, they really came alive. They felt real and you felt as if rats were really scurrying across their cold and wet surfaces."

RIGHT Sewers by Felix Presch, final line by Heiko Hentschel

LEFT Sewer decoration by Heiko Hentschel

RIGHT Mood sketch by Heiko Hentschel, based on storyboard art by Maike Ramke

FAR RIGHT Poison Box by Heiko Hentschel

LEFT Bad Blintz manhole cover by Felix Presch

EASTER EGG

Dangerous Beans looks at the chamber full of rat traps when Darktan has been captured in a cage in a scene echoing *Aliens*.

ABOVE Mood sketch by Heiko Hentschel, based on storyboard art by Maike Ramke

RIGHT Sewers by Felix Presch, final line by Heiko Hentschel

CHAPTER THREE

Smells Like...
A Mystery

Malicia Grim

The lovely Malicia Grim is the narrator of the *Mr Bunnsy* book and the feisty heroine of the story. She is arguably the most memorable character of this world full of remarkable oddballs. She is a bright, independent red-haired young girl, who perhaps has read one too many books and has based her worldview solely on her reading.

"She is my favorite character," says screenwriter Terry Rossio. "She just loves stories, and she takes us through this story with an authoritative understanding of narrative, and has sympathy and understanding for all the characters, even the villains, even herself. She also expresses the movie's theme beautifully: If you don't take action to live your own life and be the hero of your own story, you'll end up a bit player in someone else's story. And what fun is that?"

Producer Emely Christians admits, "Malicia ended up being everyone's favorite. Our director was a bit in love with her, too. She is special and strong, and she can get on people's nerves sometimes, but she's a great character and she is a great example of someone who really lives out her philosophy of being the heroine of her own story. It's also a lot of fun to see her relationship with Keith develop, because he has no idea what to do with her sometimes!"

Producer Andrew Baker is also a huge fan of the ginger-haired young lady. "We love her partly because Terry Pratchett wrote her in such an amazing way and Terry Rossio also brought her to life in the screenplay, and it's also partly her beautiful design. Then, of course, there's Emilia Clarke's amazing voice. We start the film believing that she's very naïve and that her world is all storybooks. But as the film progresses, you realize that she really does know what's going on. She's absolutely determined that her life is going to be the way she wants it to be. Malicia is the one that really comes through!"

PREVIOUS SPREAD Mr Clicky and the tunnels, early concept by Heiko Hentschel

RIGHT Malicia reading by Heiko Hentschel & Sara Leal

> "Malicia ended up being everyone's favorite... She's a great character and she is a great example of someone who really lives out her philosophy of being the heroine of her own story."

EMELY CHRISTIANS,
PRODUCER

In the early designs, Malicia had long curly red hair, a bit similar to the princess in *Brave*. "That had to be constrained due to budgetary and technical reasons," character supervisor Sophie Vickers explains. "She now has cute, shortly cropped bright-red hair, which sits with Maurice very well, because they both have ginger hair. We didn't want her to look too feminine, and were aiming for a more boyish, androgynous look. She wears this gown, but she's a bit Goth and funky. She's definitely her own person!"

Animation director Jerome Boutroux was also delighted in bringing Malicia to animated life. "She is the best lead you could ask for, and Emilia Clarke also brought so much personality to this character. We wanted to get a nice balance between her youthfulness and self-confidence. She is aware that there is a love story involved, and she knows it is going to happen between her and Keith. Of course, there is also the complexity of her constantly breaking the fourth wall and talking to the audience. In short, she was an animator's dream."

LEFT, FAR LEFT & BOTTOM LEFT Malicia by Heiko Hentschel

BELOW Malicia posing by Michael Hülse

BOTTOM RIGHT Expression sheet for Malicia by Michael Hülse

ABOVE Posing sheet for
Malicia by Michael Hülse

Malicia's Props

NOTEBOOK

"She is my favorite character. She just loves stories, and she takes us through this story with an authoritative understanding of narrative."

TERRY ROSSIO,
SCREENWRITER

MR BUNNSY BOOK

ABOVE LEFT 3D prop artwork for Malicia's notebook and pen by Red Star

ABOVE RIGHT 3D prop artwork for *Mr Bunnsy* book by Red Star, concept design by Heiko Hentschel

Farmer Fred opened his door and saw all the animals of Furry Bottom waiting for him.

ADVENTURE BAG

LEFT Malicia's adventure bag, lantern and lock pick set by Heiko Hentschel

ABOVE & RIGHT 3D artwork for Malicia's adventure bag by Red Star

LOCK PICK

LANTERN

LEFT Prop 3D artwork for lock pick set by Red Star

ABOVE Malicia's lantern by Heiko Hentschel

RIGHT 3D artwork for Malicia's lantern by Red Star

Mr Clicky

A mechanical wind-up rat toy that's used to test traps, Mr Clicky is described in the script as "A shiny, metallic rat. String tail chopped off by a trap. Staggering. Glassy eyes. Body dented."

Introduced in the earlier section of the movie, Mr Clicky also plays an important part in Malicia and Keith's dealings with the Pied Piper. As production designer Heiko Hentschel points out, "It's fair to say that Mr Clicky is the unsung hero of the movie. He has been through a lot, which one can tell by his scars, but you can always rely on him. At first I thought about giving him some kind of fake fur with lots of holes in it, but we decided to make him all metal. A sturdier material with wire whiskers, leather ears and wooden wheels. He is indeed a toy to save the day!"

BELOW Mr Clicky's bag, concept art by Gerlinde Godelmann

ABOVE, LEFT & BELOW Mr Clicky by Heiko Hentschel

"It's fair to say that Mr Clicky is the unsung hero of the movie. He has been through a lot, which one can tell by his scars, but you can always rely on him."

HEIKO HENTSCHEL,
PRODUCTION DESIGNER

ABOVE Mr Clicky color
by Michael Hülse

BELOW 3D artwork
for Mr Clicky by Alicia
Sabot & Alvin Arevalo-
Zamora

Bad Blintz

The main plot of the movie unfolds in the medieval town of Bad Blintz, which is where Maurice, Keith and the rat Clan arrive in the first act. According to Maurice, the name "Bath Blintz" (*bad* in German translates to 'bath') is reference to the residents' pride in the fact that they have a bath. To bring this offbeat location to animated life, the film's creative team spent many months looking for similar towns in Europe, finding inspiration in the general style of the old timbered houses, town squares and other typical structures.

Producer Andrew Baker notes, "The fact that the movie was set in medieval Germany appealed to our German co-producers, so from the get-go we knew the general locations of our town. When we started to develop the designs for the town, we had a rich number of references. There are buildings in parts of the country that date back to the Middle Ages. The houses in Bad Blintz have the same kinds of roofs, bottle-glass windows, beams, and overall architecture you can find in similar villages from that period."

The art and design team drew up a whole plan for Bad Blintz, with an elaborate street map

and exact location of where all the different town structures would be located. Six different buildings were created, and then elements of them were randomized to produce the rest of the structures. "It actually looked like we created fifty, since all the details were swapped, mixed and matched. It gives the impression that a whole lot of different buildings were built altogether," says Baker.

The creative team wanted to have a mix between medieval shapes and something that was close to a Victorian style. "There is the sophistication of the Victorian era mixed with handmade objects from the medieval era," production designer Heiko Hentschel notes. "We really put a lot of effort into bringing a hand-crafted feel to these backdrops. Obviously, we referred to Hamelin, because that's where the Pied Piper is from in the fairy tale. But we also combined English influences that we all loved, since the author was British. There are also some influences from the Transylvanian region of Romania, because that location [in the Discworld, Überwald] is the home of vampires, ghouls and other spooky creatures."

LEFT Bad Blintz by Edwin Rhemrev

RIGHT Bad Blintz town sign by Felix Presch

"There is the sophistication of the Victorian era mixed with handmade objects from the medieval era."

HEIKO HENTSCHEL,
PRODUCTION DESIGNER

TOP Bad Blintz houses by Edwin Rhemrev

ABOVE & RIGHT Bad Blintz by Edwin Rhemrev

The Town Gate

Like many towns in medieval Germany, Bad Blintz is protected from the outside world by its imposing gate. The arches and shapes of the sturdy gates of towns in north-eastern Europe are common landmarks. The designs of the Bad Blintz's entrance were inspired by these old structures, as well as period illustrations and medieval paintings.

The gate sports the town symbol, a double headed bat, which also features prominently in various places throughout the town, including on manhole covers, the Mayor's bed, his chain of office and the milk bottle in Malicia's kitchen.

OPPOSITE TOP Bad Blintz entrance by Felix Fresch

LEFT The road to Bad Blintz by Felix Presch

TOP LEFT Mood sketch for Bad Blintz by Felix Presch

TOP RIGHT 3D environment artwork of Bad Blintz town gate by Red Star

ABOVE Background still rendering by Rakete (Gerrit Wemmer), 3D environment artwork by Red Star

RIGHT Bad Blintz by Heiko Hentschel

Main Street & Town Square

The town's main street and town square were designed by set designer Felix Presch (*All Creatures Big and Small*, *Yakari*), who put a lot of love and hard work into the houses, sidewalks, rooftops and shops of Bad Blintz. He was inspired by the traditional half-timbered houses in Germany and northern Europe. "You will also find lots of lightning rods on top of each building, because whenever someone makes a very forceful pronouncement in Überwald you hear a lightning strike," explains production designer Heiko Hentschel.

The fountain located at the center of the town square is a clever homage to another one of Terry Pratchett's books. "Heiko came up with the idea to put a fountain shaped like the Dragon of Unhappiness in the middle of the market square," says producer Andrew Baker. "When we were doing the concept sketches, he just presented it and nobody questioned it. We both knew that the dragon came from Pratchett's *The Truth*."

BELOW Bad Blintz main street (side view) by Felix Presch

RIGHT Bad Blintz townhouses, design and final line by Felix Presch

OPPOSITE RIGHT Bad Blintz street lamp by Felix Presch

BELOW Bad Blintz townhouses by Heiko Hentschel, based on a concept by Edwin Rhemrev

"You will find lots of lightning rods on top of each building, because whenever someone makes a very forceful pronouncement in Überwald you hear a lightning strike."

HEIKO HENTSCHEL,
PRODUCTION DESIGNER

ABOVE Bad Blintz fountain sketch by Felix Presch

BELOW Bad Blintz fountain by Felix Presch

BELOW Bad Blintz currency by Gerlinde Godelmann & Heiko Hentschel

EASTER EGG

The "Dragon of Unhappiness" is mentioned but never seen in *The Truth*, in which a character suggests keeping the lid of the toilet down so that said dragon won't fly up and *inconvenience* the person sitting on it.

BOTTOM Mood sketch by Heiko Hentschel, based on storyboard art by Thomas Wellendorf

ABOVE 3D Environment artwork for town square by Red Star

BELOW Model of Dragon of Unhappiness by Red Star

ABOVE Mood sketch by Heiko Hentschel, based on storyboard art by Jo Bub

BELOW Environment modeling by Red Star

RIGHT & BELOW Rat posters, concept art by Gerlinde Godelmann & Heiko Hentschel

RIGHT & TOP LEFT Mood sketches by Heiko Hentschel, based on storyboard art by Thomas Wellendorf

THIS SPREAD Bad Blintz townhouses, design by Felix Presch, colors by Heiko Lueg

The Mayor's House & Kitchen

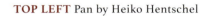

Fans of British dramas may realize that the Mayor's home and kitchen have a familiar *Upstairs, Downstairs/Downton Abbey* feel to them. "You will find a lot of brass and copper pots, gold-rimmed dinner plates, hanging herbs, cast iron elements and polished tiles," says production designer Heiko Hentschel. "I liked the British touch we achieved by mixing all those different materials. I especially love the large bright table in the center of the room. It is a perfect acting ground for our main characters."

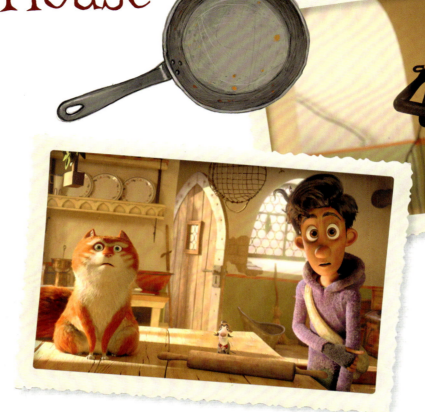

TOP LEFT Pan by Heiko Hentschel

BELOW & BELOW LEFT
Background still renderings by Rakete (Gerrit Wemmer)

LEFT Bowl with fish heads by Heiko Hentschel

"I liked the British touch we achieved by mixing all those different materials. I especially love the large bright table in the center of the room. It is a perfect acting ground for our main characters."

HEIKO HENTSCHEL,
PRODUCTION DESIGNER

ABOVE Überwald tableware pattern, milk bowl and bottle, concept art by Heiko Hentschel

RIGHT Mayor's kitchen sketch by Felix Presch

BELOW Meeting Malicia, early concept by Heiko Hentschel

TOP & MIDDLE RIGHT Mayor's kitchen concept sketches by Felix Presch

ABOVE & RIGHT Mayor's kitchen sketches by Felix Presch

THIS PAGE 3D environment artwork of the Mayor's kitchen by Red Star

Unseen University Rubbish Dump

EASTER EGG

The wizard throwing a bucket of rubbish onto the dump behind Unseen University is Rincewind, the main character in several other Discworld books, including the first, *The Color of Magic*. The rubbish on the dump also includes banana peels and peanut shells from the university's Librarian, who is an orangutan.

RIGHT Rincewind by Heiko Hentschel, inspired by Paul Kidby

ABOVE Rincewind by Paul Kidby

ABOVE Wizard cloak pattern by Heiko Hentschel

RIGHT Rincewind sketch by Heiko Hentschel, inspired by Paul Kidby

BELOW Rubbish dump behind Unseen University, design and final line by Tom Olieslagers, inspired by Paul Kidby

BELOW Magical garbage by Heiko Hentschel

LEFT Mood sketches by Heiko Hentschel, based on storyboard art by Jo Bub

ABOVE The university's Tower of Art by Paul Kidby

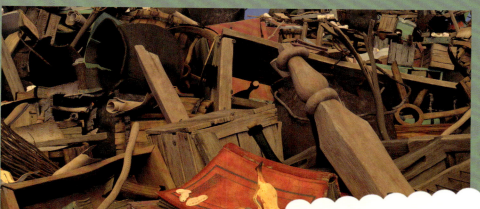

LEFT & ABOVE 3D environment artwork of the rubbish dump by Red Star

BELOW LEFT Bucket with magical garbage by Heiko Hentschel

BELOW Background still rendering by Rakete (Gerrit Wemmer)

Something Horrible, Yet Interesting!

LOCATION FOCUS

Location Focus: The Ratcatchers' Guild

Every movie has a certain location or backdrop that stays with audiences long after the roll of the closing credits. The Ratcatchers' Guild in *The Amazing Maurice* is one of those strange and unique spots. This is, after all, where we witness the manifestation of the evil ratcatchers and their brutal ways.

"We have a lot of fascinating locations in the movie, from the Mayor's bedroom to the 'Dark Wood' and the Pied Piper's creepy cottage," producer Andrew Baker explains, "but the Ratcatchers' Guild leapt out as the pivotal location for the film. It's also the place we visit more than any other. In any fairy story there is always a villain, and in our film we have more than one, so the Guild is key in that it not only represents the underlying 'evil' of the ratcatchers and their historically brutal trade, but also is the place where the Rat King was created and hence is at the core of his plot to starve the humans or, as he puts it, 'the rats getting stronger, the humans getting weaker.'"

Baker points out that the Guild is a dirty room full of junk, but it's also deliberately mundane and commonplace. "We have the cups for the ratcatchers' tea, alongside bottles of poison and traps. It is also practical, with the tools of their trade and rat traps scattered everywhere, alongside the fantastical – a hidden trap door reveals the cellars where there is an Aladdin's cave full of food! We also see the room through different eyes in each visit – it is where the ratcatchers live and work, yet it is also where they report to the Boss Man, whom they fear and obey, who is magical and extraordinary."

ABOVE & BELOW
Background still renderings by Rakete (Gerrit Wemmer)

PREVIOUS SPREAD Mood sketch by Heiko Hentschel, based on storyboard art by Felix Schichl

ABOVE The Ratcatchers' Guild sketch by Felix Presch **ABOVE RIGHT** Inside the Guild house by Felix Presch **BELOW** Inside the Ratcatchers' Guild by Felix Presch

"Many pivotal moments take place here, so it needed to be rich from every camera angle and very well thought through."

TOBY GENKEL,
DIRECTOR

The Guild was the first set that was designed for the movie, and it somewhat established the style for the entire film. "One set to rule them all, so to speak," director Toby Genkel jokes. "We were looking for a rather funny and crooked style. Clean and slick would not fit Terry Pratchett's universe very well. We wanted to feel the author's humorous, detail-loving and wicked eye on the world in every detail. In addition, we spend a lot of screen time in this location. Many pivotal moments take place here, so it needed to be rich from every camera angle and very well thought through."

Genkel adds, "The Guild can be viewed as the headquarters of our baddies and like every set it is a character in itself, defining and drawing a clear picture of who lives there. I hope it speaks clearly that whoever resides here is up to no good – and

OPPOSITE TOP Interior of the Ratcatchers' Guild by Felix Presch

OPPOSITE BOTTOM LEFT Inside the Ratcatchers' Guild by Felix Presch

LEFT Interior details of the Ratcatchers' Guild by Heiko Hentschel

ABOVE Ratcatchers' Guild color concept by Heiko Hentschel

RIGHT Mood sketch for the Ratcatchers' Guild by Heiko Hentschel

they don't care for dusting either. We had this idea that Ron or Billy's parents were pharmacists and bequeathed them a well-established pharmacy. We can see what they turned it into!"

"The Guild was basically the one location that helped us define the modeling style for all other sets," production designer Heiko Hentschel explains. "How crooked is the furniture? How many textures and colors can we mix before the eye loses focus? How much dirt can one add, before it gets too

much for family entertainment? Questions like this were answered as we worked on this location. I was pushing for an old pharmacy interior. That's why we've added a cabinet with lots of small drawers, a big counter, a scale and dozens of medicine and powder bottles. But I can assure you there is no wholesome medicine to be found inside!"

The audience gets to see the Guild at different times of the day, and each scene is influenced by the lighting. "At first, when we see the Boss Man eating,

> ## "I hope it speaks clearly that whoever resides here is up to no good."
>
> TOBY GENKEL,
> DIRECTOR

OPPOSITE 3D environment modeling of the Ratcatchers' Guild by Red Star

THIS PAGE Texturing and shading of the Ratcatchers' Guild by Red Star

it is lit by daylight sun," Baker notes. "The location is still dirty and full of junk, but does not seem too evil or foreboding – just strange. When we visit it again, the light is more limited and Malicia's lamp picks out strange shapes and objects that start to introduce an element of menace – a mini guillotine with a stuffed headless rat, a dead plant, bottles of rat poison and a scary-looking trap that closes with a snap and startles Keith – and so it becomes the perfect setting to investigate our mystery. As Malicia would say, 'Ominous!' When we visit for the third time it is well lit by overhead lamps," the producer concludes. "The darkness is banished and we see the ratcatchers clearly, the food piled high on the counter, and the mystery is resolved!"

"I can assure you there is no wholesome medicine to be found inside!"

HEIKO HENTSCHEL,
PRODUCTION DESIGNER

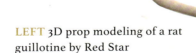

LEFT 3D prop modeling of a rat guillotine by Red Star

ABOVE Box with "Killalot" by Heiko Hentschel

RIGHT Different canisters with poison by Heiko Hentschel

ABOVE Rat poster design by Heiko Hentschel, 3D prop artwork by Red Star

TOP MIDDLE Various bottles of liquid poison by Heiko Hentschel

TOP RIGHT Box of rat poison by Heiko Hentschel

RIGHT Collection of notes, recipes and sketches found in the Ratcatchers' Guild by Heiko Hentschel

Once the style of the Guild was approved, Hentschel did some color sketches of the location during different times of the day. The mood that stood out in the script was the one where the protagonists search the house for clues to solve the town's mystery. "Outside the sun goes down, while inside we have the greenish spotlight from Malicia's lamp shining on the dark floorboards," he says. "It was great fun to play with these different colors. Later, in the mood board, I limited the color of the light inside the main room to an oversaturated yellow. This emphasizes all the green parts of the furniture and adds a poisonous touch to the final shots."

RIGHT & BOTTOM Mood sketches by Heiko Hentschel, based on storyboard art by Felix Schichl

TOP LEFT Cellar below the Ratcatchers' Guild by Tom Olieslagers

TOP RIGHT Mood sketch by Heiko Hentschel, based on storyboard art by Felix Schichl

ABOVE 3D environment artwork of a Guild cellar by Red Star

LEFT Cellar below the Ratcatchers' Guild by Felix Presch

ABOVE Empty food cellar by Tom Olieslagers

RIGHT 3D prop artwork of pretzels by Red Star

BELOW Filled food cellar by Felix Presch

ABOVE Slim barrel, wine bottle and onions by Tom Olieslagers

LEFT Empty basket by Tom Olieslagers

"It actually triggers my curiosity and makes me want to open every single drawer or box."

TOBY GENKEL,
DIRECTOR

The production designer admits that working on a crowded, dirty set with lots of objects and knick-knacks is always challenging. "But our modeling team, as well as the texturing and rendering department, were determined not to give up until it looked just right," he adds. "They did a stunning job."

What Genkel ultimately loves about this location is that it provides a quick backstory about its owners. "It's beautiful and ugly at the same time. It actually triggers my curiosity and makes me want to open every single drawer or box. It also sends chills down my spine, because I know I may not like what I find there. And we haven't even spoken about the secret that lies underneath the floorboards!"

Baker loves the fact that the Guild drives the story narrative forward so well. He concludes, "It's exactly what Malicia wants it to be: 'something horrible, yet interesting. Some ghastly clue that would advance the plot.'"

ABOVE Ham, salami, sweet bun, pumpkin, sack of flour, pickles and lollipop by Tom Olieslagers

BELOW Canned sardines and peaches by Tom Olieslagers, color by Heiko Hentschel

"Our modeling team, as well as the texturing and rendering department, were determined not to give up until it looked just right."

TOBY GENKEL,
DIRECTOR

THIS IMAGE Mood sketch by Heiko Hentschel, based on storyboard art by Felix Schichl

OPPOSITE TOP Background still rendering by Rakete (Gerrit Wemmer)

RIGHT Food cellar, 3D environment by Red Star

LEFT Cellar with ceiling detail and rat cage by Tom Olieslagers

BELOW LEFT Rat cellar with and without cages, concept art by Tom Olieslagers

BELOW Rat cellar filled with cages by Tom Olieslagers

LEFT Lock and key, prop artwork by Red Star

TOP RIGHT Mood sketches by Heiko Hentschel, based on storyboard art by Felix Schichl

BELOW Rat cages, 3D environment by Red Star

LEFT Ratcatchers' Guild side view by Felix Presch, color by Heiko Lueg

BELOW Ratcatchers' Guild front view sketch by Felix Presch

BOTTOM LEFT Ratcatchers' Guild in situ and sign, 3D environment by Red Star

BOTTOM RIGHT Mood sketch by Heiko Hentschel, based on storyboard art by Jo Bub

> **"The Ratcatchers' Guild leapt out as the pivotal location for the film. It's also the place we visit more than any other."**
>
> ANDREW BAKER,
> PRODUCER

CHAPTER FOUR

So – What's Your Plan?

Rooftops

The rooftops of Bad Blintz were inspired by structures seen in medieval village designs. The key aspect of this backdrop was that a lot of attention needed to be paid to small details, since we see most of these locations from the perspective of the rats, rather than Maurice or the humans.

"The rooftops and the foundry were created to serve the story," says production designer Heiko Hentschel. "They are story-driven locations, so we don't spend a lot of time there. We're just passing though. The most important thing was to create enough detail so that the scenes would hold up from the perspective of the rats."

PREVIOUS SPREAD & BELOW Mood sketch by Heiko Hentschel, based on storyboard art by Gaelle Beehrens

RIGHT Road to Bad Blintz, 3D environment by Red Star

OPPOSITE BOTTOM Bad Blintz from a rat's point of view by Edwin Rhemrev

OPPOSITE BOTTOM RIGHT Rooftops with iron foundry by Felix Presch

"The most important thing was to create enough detail so that the scenes would hold up from the perspective of the rats."

HEIKO HENTSCHEL,
PRODUCTION DESIGNER

The Mayor's Bedroom

Since the film doesn't spend much time in the mayor's bedroom, the number of elements featured in this space were kept to a minimum. The basic focus is on the eye-catching patterns for the walls, the curtains and the bed sheet. The main inspiration was a royal bedroom, with lots of dark violet colors and silver featured in lieu of gold.

RIGHT Mayor's bedroom by Tom Olieslagers

BELOW Mayor's bedroom sketch by Tom Olieslagers

BELOW RIGHT Pattern suggestions for walls, curtains and bed sheet by Heiko Hentschel

ABOVE Mayor's bedroom color by Heiko Hentschel

RIGHT Mood sketch by Heiko Hentschel, based on storyboard art by Gaelle Beehrens

BELOW Mayor's bedroom, 3D environment by Red Star

The Iron Foundry

The town's iron foundry is the location for the terrifying encounter between the brave and spotlight-loving Sardines and Brute "the Cute," the fighting chihuahua. "The foundry is almost a character itself," says production designer Heiko Hentschel. "The wooden circular area is where the dogs chase the rats. We needed a wide open space for these hunting sequences. Sardines needed to have some room to play for his big number. Since the pit is mainly empty, the rest of the surroundings needed to have space for the town spectators who are betting on the dogs or the rats. The structure felt like an abandoned train station. I researched a lot of iron foundries, and the one that stood out for me was one that was based in India. People are weary and have been doing very hard work. The only light is the dim one that shines on the pit."

RIGHT Iron foundry sketch by Felix Presch

BELOW 3D environment of external iron foundry by Red Star

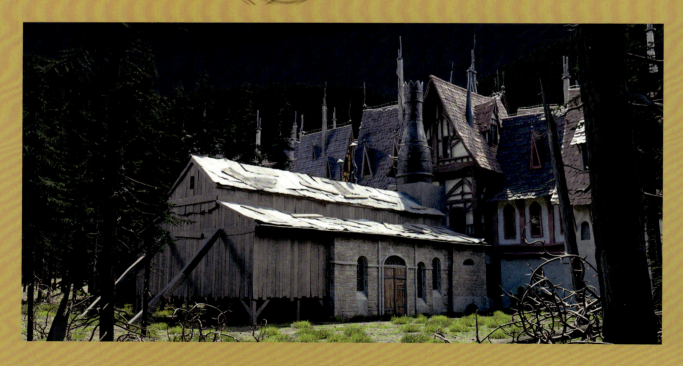

BOTTOM Iron foundry by Felix Presch

BELOW Iron foundry shape exploration by Felix Presch

FAR RIGHT Final iron foundry by Tom Olieslagers

RIGHT Mood sketches by Heiko Hentschel, based on artwork by Tom Olieslagers

ABOVE Iron foundry (inside) by Felix Presch

LEFT Mood sketches by Heiko Hentschel, based on storyboard art by Gaelle Beehrens

BELOW Iron foundry (inside), final concept and details by Tom Olieslagers

ABOVE Mood sketch by Heiko Hentschel, based on storyboard art by Gaelle Beehrens

LEFT 3D prop for the lantern, artwork by Red Star

BELOW MIDDLE Lantern design by Heiko Hentschel

> ## "The foundry is almost a character itself."
>
> HEIKO HENTSCHEL,
> PRODUCTION DESIGNER

ABOVE Iron foundry internal set, 3D environment by Red Star

LEFT Betting board on oil drums by Tom Olieslagers

Rat Pit Characters

ABOVE The rat pit, early concept by Heiko Hentschel

ABOVE RIGHT Mood sketches by Heiko Hentschel, based on storyboard art by Gaelle Beehrens

RIGHT Jacko by Heiko Hentschel

BELOW Model sheet and details for Jacko by Gerlinde Godelmann

ABOVE Brute "the Cute" by Heiko Hentschel

RIGHT Model sheet and details for Brute by Gerlinde Godelmann

ABOVE Expressions and posings for Jacko and Brute "the Cute" by Michael Hülse

LEFT Handler by Heiko Hentschel

RIGHT Thug with dogs, Handler and Gambler posing exploration by Michael Hülse

LEFT Furious Gambler by Michael Hülse

BOTTOM LEFT Handler running from Jacko by Michael Hülse

BELOW Thug and Gambler by Heiko Hentschel

CHAPTER FIVE

There's Something Terrible in the Dark Wood

The Forest

You really can't have a proper fairy tale setting without a visit to a German forest. In the movie, Malicia and Keith head out to the "Dark Wood" in search of the real Pied Piper and his magic flute. For the scene, the forest had to look familiar, yet also dark and foreboding. Co-director Florian Westermann explains, "We wanted a straightforward approach to the 'Dark Wood,' because we didn't want it to look lush and beautiful, with butterflies fluttering around. The goal was to make it very basic, so that the fantastic parts of the story, like the Rat King story, would stand out more."

"I loved the basic concept of how we were going to treat the forest early on," says production designer Heiko Hentschel. "The goal was to have something a bit more abstract than photorealistic trees, bushes and vegetation. We started out by looking at regular forests in Germany and Romania. Then I stripped them to basic shapes. Although it's in the middle of the night, we have this invisible light, almost like a ray of sun surrounded by black trees. Some of the bushes had hints of golden leaves, and others were designed to look like barbed wire. Right in the middle of this dark forest, you have the colorful home of the Pied Piper, which looks sugarcoated and is candy colored. It makes a big impact."

PREVIOUS SPREAD Mood sketch by Heiko Hentschel, based on storyboard art by Gaelle Beehrens

ABOVE Background rendering by Gerrit Wemmer

BELOW "Dark Wood" shape exploration by Felix Presch

BELOW LEFT Tree shape exploration by Felix Presch

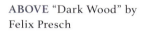

ABOVE "Dark Wood" by Felix Presch

LEFT Dark forest clearing by Felix Presch

RIGHT Cliff in the middle of the "Dark Wood" by Felix Presch

BELOW Cliff with big rock shape exploration by Felix Presch

ABOVE "Dark Wood" exploration by Felix Presch

BELOW The path through the "Dark Wood" by Felix Presch

BELOW & RIGHT The "Dark Wood," 3D environment by Red Star

TOP Cliff with big rock by Felix Presch

BELOW The "Dark Wood" leading to the ravine, 3D environment by Red Star

EASTER EGG

The scene where Malicia swings with Keith across a ravine is a callback to a similar one in *Star Wars* with Luke and Leia on the Death Star.

BELOW Cliff shape exploration by Felix Presch

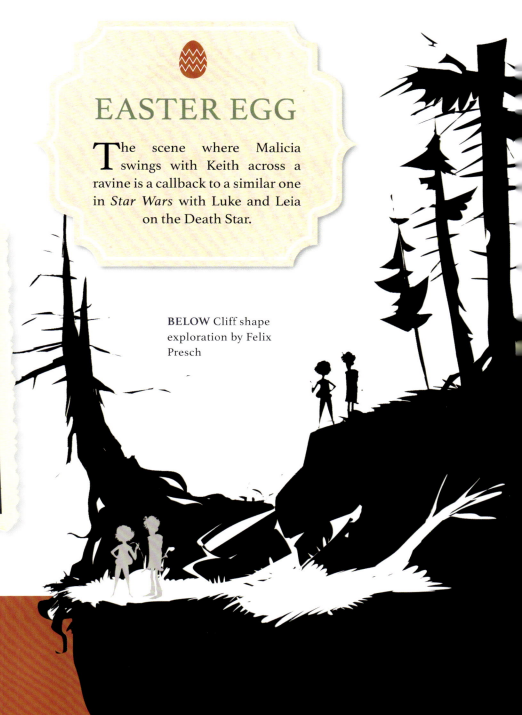

The Pied Piper

One of the oddest and creepiest secondary characters in the movie, the Pied Piper adds another layer of weirdness to the story. The origins of the character go back to German folk tales from the Middle Ages, which were compiled in the 1812 book by the Brothers Grimm, *Children's and Household Tales* (later called *Grimms' Fairy Tales*). In search of the magic pipe, Malicia and Keith encounter the tall and nimble character deep in the heart of the forest.

"There is nothing bland about the design of our Piper. He has been designed to look very odd," producer Andrew Baker notes. "He has these spindly legs and holes in his tights, and looks quite insane."

Production designer Heiko Hentschel agrees. "He is a very creepy dude! I just love how he turned out in the final design. Since he is a classic fairy tale character from Germany, we did a lot of research on the real Pied Piper of Hamelin. We decided to give him some medieval harlequin vibes mixed with faded rococo makeup. I limited the color palette for his costume to red and black and added a few strong neon tones to the hat and the puffed-up trousers.

"His pipe was a very wonderful task," Hentschel adds. "We tried to make it look elegant and shiny, with a rat-shaped mouthpiece. It is a clear contrast to the simple pipe Keith plays earlier on."

RIGHT Annoyed Pied Piper by Michael Hülse

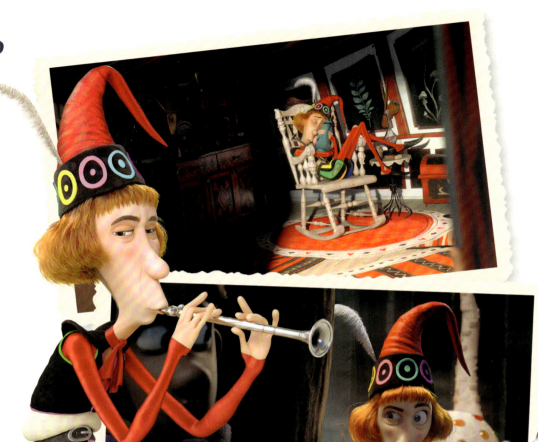

RIGHT The Pied Piper's pipe by Heiko Hentschel

"There is nothing bland about the design of our Piper. He has been designed to look very odd."

ANDREW BAKER,
PRODUCER

ABOVE Model sheet and details for the Pied Piper by Gerlinde Godelmann

LEFT Pied Piper by Heiko Hentschel, based on a design by Carter Goodrich

LEFT Napping Pied Piper on rocking chair by Michael Hülse

ABOVE Pied Piper with pants on fire by Michael Hülse

The Pied Piper's Shack

Early in the production, it was proposed that the Pied Piper's shack in the middle of the forest should look haunted and deserted. But the directors and producers wanted it to have a more classic fairy tale look on the outside, something that would echo the witch's house in another Grimm fairy tale, *Hansel and Gretel*, which is made of candy, sugar, cake and lollipops.

"We took this idea and added some special lighting for the outside of the house," says production designer Heiko Hentschel. "The idea was that it's always sunny around the house, no matter what time of day it is. This makes you

feel even more uncomfortable than a 'haunted house' would do.

"The inside of the house feels as if you have stepped inside a cuckoo clock. Carpets, doilies, knick-knacks and traditional wood-carvings would normally have a cozy vibe, but here the color palette and surreal lighting have the exact opposite effect."

BELOW The shack, early concept by Heiko Hentschel

LEFT The Pied Piper's shack by Felix Presch

ABOVE & RIGHT Well and fence post for the Pied Piper's shack, 3D environment by Red Star

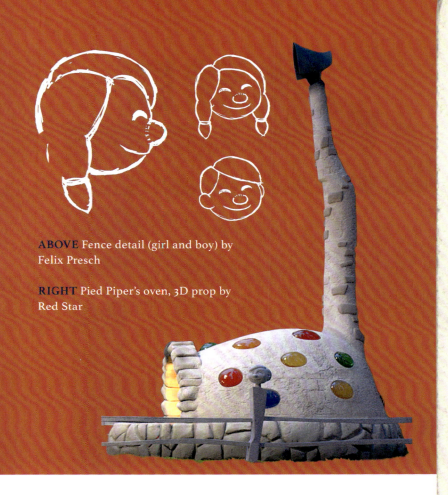

ABOVE Fence detail (girl and boy) by Felix Presch

RIGHT Pied Piper's oven, 3D prop by Red Star

OWL

ABOVE Owl by Heiko Hentschel, color by Michael Hülse

TURKEY

LEFT & ABOVE Turkey by Heiko Hentschel, color by Michael Hülse

LEFT Mood sketches by Heiko Hentschel, based on storyboard art by Gaelle Beehrens

ABOVE Stuffed turkey by Heiko Hentschel

> "The inside of the house feels as if you have stepped inside a cuckoo clock."

HEIKO HENTSCHEL,
PRODUCTION DESIGNER

ABOVE Detailed clock, 3D prop by Red Star

RIGHT, TOP & TOP RIGHT Painted wooden panels and doors by Heiko Hentschel

RIGHT CENTER Interior of the Pied Piper's shack by Felix Presch

FAR RIGHT Artwork by Heiko Hentschel

TOP Mood sketches by Heiko Hentschel, based on storyboard art by Gaelle Beehrens

ABOVE Carpet color design by Heiko Hentschel, based on a sketch by Felix Presch

LEFT Internal set of the Pied Piper's shack, 3D artwork by Red Star

CHAPTER SIX

Just a Cat

Rat King

PREVIOUS SPREAD, ABOVE & RIGHT
Mood sketch by Heiko Hentschel, based on storyboard art by Thomas Wellendorf

ABOVE The Rat King "Crown" by Heiko Hentschel

RIGHT Generic rat by Gerlinde Godelmann

BELOW Generic and clever rats by Heiko Hentschel

TOP Boss Man posing by Michael Hülse

ABOVE Boss Man evolution by Heiko Hentschel

RIGHT Boss Man by Heiko Hentschel

Maurice the Tiger & Spirit Maurice

ABOVE Mood sketch by Heiko Hentschel, based on storyboard art by Thomas Wellendorf

LEFT, TOP & RIGHT Battered Maurice posing by Michael Hülse

BELOW Battered Maurice by Heiko Hentschel

RIGHT Death and Maurice posing by Michael Hülse

BOTTOM 3D artwork of Battered Maurice by Amandine Bernard & Jordan Soler

BELOW Death and Maurice by Heiko Hentschel, inspired by Paul Kidby

Death

The imposing character of Death is one of the most iconic in Terry Pratchett's Discworld series. He also likes cats. In this tale, Death comes face to face with Maurice and has a pivotal exchange with our feline hero in the film's final act. The creative team knew that they wanted to go back to Discworld book illustrator Paul Kidby's inventive and highly expressive drawings as their key source of inspiration for this character.

Kidby says Death has always been one of his favorite characters. Partly because, when he began to draw him, he finally had the opportunity to put his youthful studies of anatomy to great use.

"The design has evolved over the years and I still make adjustments each time I return to illustrate him," he explains. "It is always a challenge to work against hundreds of years of established iconography depicting the Grim Reaper. Terry gave him a kindly disposition and my task is to capture this so the reader can feel a different reaction to him, rather than the standard response to a cowled skeleton. I have a life-sized skeleton for reference."

BELOW Mood sketch by Heiko Hentschel, based on storyboard art by Maike Ramke

FAR LEFT The Afterlife, early concept by Heiko Hentschel

LEFT Scythe 3D prop artwork by Red Star, inspired by Paul Kidby

BELOW & RIGHT Death explorations by Heiko Hentschel

PAUL KIDBY ILLUSTRATIONS

CLOCKWISE FROM TOP LEFT
*Death with Kitten II, Death with
Steepled Fingers, Reaper Man, Death
with Skeletal Steed* by Paul Kidby

"Terry gave [Death] a kindly disposition and my task is to capture this."

PAUL KIDBY,
DISCWORLD BOOK ILLUSTRATOR

ABOVE Death by Heiko Hentschel

RIGHT Death by Heiko Hentschel, inspired by Paul Kidby

BELOW Death posing by Michael Hülse

The Bone Rat

Discworld book illustrator Paul Kidby explains that the Bone Rat, aka the Death of Rats, aka the Grim Squeaker, is the rat world equivalent of Death. "When I initially came to design this character, I sourced and illustrated a rat's skull, but found it somehow did not seem cheery enough," he recalls. "When I combined it with elements of a rabbit skull it somehow seemed more jolly. Don't ask me why – it's strange but true!"

LEFT, RIGHT & BELOW The Bone Rat posing by Michael Hülse

BELOW Mood sketch by Heiko Hentschel, based on storyboard art by Thomas Wellendorf

RIGHT & BELOW
Death of Rats by Paul Kidby

RIGHT The Bone Rat by Heiko Hentschel, inspired by Paul Kidby

The Amazing Maurice And His Educated Rodents

Bad Blintz Prosperous

When we first see the town of Bad Blintz, it's in the midst of a famine – the townsfolk are hungry and there's no food to be seen. In fact, Keith comments, "It's a bit odd for a market town not to have a market!" So, after the Boss Man has been defeated and prosperity has returned, the filmmakers wanted to show Bad Blintz at its best. "We hung bunting across the town square and had tables of food, busy market stalls, etc.," says producer Andrew Baker. "In reference to the original novel, we wanted to show Maurice and the Mayor on the balcony together, waving to the townspeople. The crowds are also a marked contrast to the original scenes where Maurice and Keith arrive in deserted and quiet Bad Blintz. The town is now a tourist attraction, with the rats dancing and walking in line behind Keith and people celebrating and having fun."

While the town itself remains the same – the stalls and bunting are added extras – one thing that is different is the central focus of Bad Blintz. "Instead of the fountain we added the 'rat town' where the rats live and go to school," Baker points out. "In honor of the original novel, we also wanted to include some of the rat language that Peaches writes and so the school for rats includes some of these designs.

"The other change was the townsfolk. We see some familiar faces but everyone – from the Mayor to the pit gambler – is now dressed in their finest, with brighter colors, gold trim and very much cleaner clothes on display!"

PREVIOUS SPREAD & TOP LEFT Mood sketch by Heiko Hentschel, based on storyboard art by Maike Ramke

RIGHT Bad Blintz market square with stalls, 3D environment by Red Star

LEFT Coat of arms of Bad Blintz by Gerlinde Godelmann & Heiko Hentschel

RIGHT & BELOW Bad Blintz banners and decoration by Heiko Hentschel

FAR RIGHT Bad Blintz prosperous by Felix Presch

BELOW Bad Blintz kids with rat ears by Heiko Hentschel

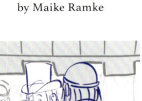

LEFT Market booth by Felix Presch, color by Heiko Hentschel

BELOW Storyboard art by Maike Ramke

TOP Bad Blintz prosperous by Felix Presch

LEFT & RIGHT Merchandising and Bad Blintz family by Heiko Hentschel

FAR LEFT Close ups of the market stalls, environment artwork by Red Star

BELOW Market booths and Bad Blintz souvenir cup by Felix Presch, color and pattern by Heiko Hentschel

Tourist

The final scene of the movie includes a shot of a wizard – Rincewind again – with a rat on his shoulder having his photograph taken by a tourist. The photographer is recognizable as Twoflower, the optimistic and naive tourist character who travels with Rincewind in *The Color of Magic* and appears in two other books.

TOP & RIGHT The tourist by Heiko Hentschel, inspired by Paul Kidby

ABOVE Aloha pattern by Heiko Hentschel

BELOW Close up of details of the tourist, 3D artwork by Amandine Bernard & Alvin Arevalo-Zamora

Mr Clicky's Family

WIFE

KIDS

RIGHT Model sheet and details for Mr Clicky's kids by Gerlinde Godelmann

BOTTOM Mr Clicky's child #1 by Heiko Hentschel, color by Michael Hülse

ABOVE Model sheet for Mr Clicky's wife by Gerlinde Godelmann & Heiko Hentschel

BELOW 3D models of Mr Clicky and his family. Character modeling by Alicia Sabot & Lilian Robert

ABOVE Mr Clicky's wife by Heiko Hentschel, color by Michael Hülse

Bad Blintz Rat Town

LEFT Bad Blintz rat town by Felix Presch

ABOVE Background still rendering by Rakete (Gerrit Wemmer)

BELOW & OPPOSITE BOTTOM LEFT Mood sketches by Heiko Hentschel, based on storyboard art by Maike Ramke

ABOVE & RIGHT Color concept for the rat town by Heiko Hentschel

FAR RIGHT Rat posters for Bad Blintz by Gerlinde Godelmann

BELOW RIGHT Dreams come true, early concept by Heiko Hentschel

Rat School

THIS PAGE Model sheets and details for rat kids by Gerlinde Godelmann, color by Heiko Hentschel

EASTER EGG

The final marketplace scene of the movie includes a shot of kid rats at school. There are some of the rat language signs from *The Amazing Maurice and His Educated Rodents* book on the blackboard.

We co-operate, or we die.

Not to Widdle where you Eat.

No Rat to Kill Another Rat.

ABOVE School book with rat language signs by Heiko Hentschel, based on illustrations by David Wyatt

RIGHT Rat boy by Heiko Hentschel

TOP RIGHT Replica of the rat language signs from *The Amazing Maurice and his Educated Rodents* book, based on illustrations by David Wyatt

LEFT & ABOVE Storyboard art by Maike Ramke

A Framing
Device

Animating the Storybook World of Mr Bunnsy

Fans of Pratchett's book know that each chapter begins with a little quote from *Mr Bunnsy Has An Adventure*, a twee children's illustrated book reminiscent of Beatrix Potter's *Peter Rabbit* series. The movie's creative team had a great idea about how to incorporate these meta moments: create 2D-animated pieces that are seen as Malicia Grim reads excerpts to her audience.

"The way our writer, Terry Rossio, had written it was brilliant, because we have Malicia breaking the fourth wall and talking to the audience on multiple occasions," says producer Andrew Baker. "Not only is this a funny take on the Beatrix Potter books, it also offers a window to the world of the rats, who believe this book to be their bible. This is what the rats believe in, so we wanted to do it justice."

Once production designer Heiko Hentschel created the concept art for the *Mr Bunnsy* book, it

seemed like a natural choice to have him also create the 2D animation for the brief clips. "What he came up with was so beautiful and we didn't want someone else to change or interpret it," explains Baker. "He produced the 2D sections using TVPaint and Photoshop in eight weeks. The animation is deliberately simple and a lot of fun to have within the rest of the CG-animated movie."

"In the book, Mr Bunnsy's actions foreshadow the story in a few lines before each chapter, which is a brilliant storytelling move," says Hentschel. "That's why we wanted to do something similar at pivotal points of the movie. Therefore, the sequences needed to be carefully selected."

He says initially they were thinking about a style that looked like medieval tapestry – stylized animals that tell the story on a woven surface with ornate letters. "But when we figured out that Sir

PREVIOUS SPREAD, LEFT & TOP Mood sketch by Heiko Hentschel, based on storyboard art by Jo Bub

ABOVE Storyboard art by Gaelle Beehrens

OPPOSITE Style frame for the *Mr Bunnsy* storybook by Heiko Hentschel, based on a layout by Tom Olieslagers

Terry Pratchett had a special fondness for Beatrix Potter, we knew that this should be our only reference. So we looked at her art, studied the way she approached landscapes and colored her world-famous illustrations. That was our key to find Mr Bunnsy's home."

According to Hentschel, the colorization of the animation was the toughest part. "We did every drawing in TVPaint by hand to achieve the watercolor look. This caused some nice random effects that kept the balance between a handmade look and a technical approach. The colors are not moving around too much to drag the attention away from the action, but are 'busy' enough to keep it alive. I like to call it controlled chaos!"

The artist is quite pleased with the clever *Mr Bunnsy* interstitials. "It was great to have living, breathing 2D animation in a 3D feature movie," he concludes. "The fact that it is drawn and colored by hand adds a magical layer, because hand-drawn animation does not need to be perfect. The imperfections are what make it alive."

The team had a lot of fun coming up with entertaining scenarios and visuals for the storybook rabbits. "Heiko came up with the notion that Mr Bunnsy should always be having his tea during all the scenes, with his pinky raised," says Baker. Adding, "We had so much fun playing with these characters that we are now actually writing the rest of the *Mr Bunnsy* book, with Heiko doing all the illustrations!"

Mr Bunnsy

"**Terry Pratchett had a special fondness for Beatrix Potter… That was our key to find Mr Bunnsy's home.**"

HEIKO HENTSCHEL,
PRODUCTION DESIGNER

LEFT Mr Bunnsy
by Heiko Hentschel

TOP RIGHT Early
Mr Bunnsy design
by Heiko Hentschel

RIGHT Mr Bunnsy
and Ratty Rupert
by Heiko Hentschel

THIS PAGE Mr Bunnsy model sheet poses by Gerlinde Godelmann & Heiko Hentschel

RIGHT Early Mr Bunnsy by Heiko Hentschel

Mr Bunnsy Characters

LEFT Ratty Rupert by Heiko Hentschel

BELOW Little Owl model sheet poses by Gerlinde Godelmann

LEFT Early Ratty Rupert by Heiko Hentschel

RIGHT Hen model sheet poses by Gerlinde Godelmann

FAR RIGHT Howard the Stoat model sheet poses by Gerlinde Godelmann

BELOW Olli the Snake model sheet poses by Gerlinde Godelmann

BOTTOM & OPPOSITE BOTTOM Furry Bottom color lineup by Heiko Hentschel

Mr Bunnsy Locations

RIGHT *Mr Bunnsy* layouts by Tom Olieslagers

BELOW *Mr Bunnsy* layout by Tom Olieslagers, final line by Heiko Hentschel

ABOVE Final backgrounds by Heiko Hentschel

RIGHT Mood sketch by Heiko Hentschel, based on storyboard art by Jo Bub

Mr Bunnsy Has An Adventure Book

ABOVE Storybook cover suggestions by Heiko Hentschel

TOP RIGHT Early style suggestions for the book illustrations by Heiko Hentschel, inspired by medieval tapestry

RIGHT Lettering suggestions by Heiko Hentschel, inspired by medieval calligraphy

BELOW Inner parts of *Mr Bunnsy Has An Adventure* (rat edition) by Heiko Hentschel

Ratty Rupert dolor sit amet, consetetur elitr, sed diam nonumy eirmod tempor invidunt ut labore et dolore voluptua.

Mr Bunnsy lorem ipsum dolor sit amet, consetetur sadipscing elitr, sed diam nonumy eirmod tempor invidunt ut labore et dolore magna aliquyam erat, sed diam voluptua.

BELOW Inner parts of *Mr Bunnsy Has An Adventure* (rat edition), color by Heiko Hentschel

Ratty Rupert lorem set dolor sit amet, consetetur sadipscing elitr, sed diam invidunt ut labore et aliquyam erat sed diam .

Olly the Snake dolor consetetur sadipscing elitr, sed diam nonumy eirmod dolore magna aliquyam erat diam .

ABOVE Cover for *Mr Bunnsy Has An Adventure* (rat edition) by Heiko Hentschel

ABOVE RIGHT Cover for *Mr Bunnsy Has An Adventure* (human edition) by Heiko Hentschel

BELOW & RIGHT The tatty (rat edition) of the *Mr Bunnsy* book, 3D prop by Red Star

Color Script

THIS SPREAD Color script for *The Amazing Maurice* by Heiko Hentschel

Conclusion

When it comes to unusual and fantastic characters, you can't really do better than Terry Pratchett's feline star, Maurice. Here is a clever tabby who has been able to make an easy life for himself by manipulating both the rat and human populations around him. For the creative team behind this year's highly entertaining animated feature about this amazing cat, staying true to the words of the acclaimed author and his trademark wit and worldview was particularly important. As *The Amazing Maurice* opens in theaters around the world, the talented people behind the movie hope audiences will enjoy their labor of love and rediscover the magic of Pratchett's rich fantasy.

"I am very pleased with the film's beautiful animation and what we were able to achieve with a European movie's budget," says producer Emely Christians. "Our goal was to be true to the spirit of Pratchett's much-loved creation. I hope viewers will get the ultimate message of the movie, which is that we should be able to live in peace together and not fight for our own selfish individual needs."

"We are all very proud of the movie," notes director Toby Genkel. "I hope our audience is entertained for ninety minutes. Pratchett had some important things to say about humanity and the value of democracy and diversity and showing respect for others. In addition to all the fun and amazing imagery, I hope viewers can take home these messages as well."

"Although it was important for us to make a movie that was entertaining for the whole family, we didn't want to lose the special Pratchett touch and perspective," says co-director Florian Westermann. "I hope the action elements, the clever humor and the entertaining characters will also introduce a new generation of fans to Pratchett's fantasies. We worked very hard on the emotional beats of the story."

Producer Robert Chandler hopes the die-hard fans of Pratchett will recognize the filmmakers'

team effort and appreciate the adaptation on its own terms. "The author's fans are very loyal and passionate," he says. "We truly wanted to do justice to his words and, at the same time, make a great animated movie. In the end, I hope we were able to honor the complexity and intelligence of his worldview and what he had to say about these characters who are ultimately courageous in the face of adversity. I am also quite happy with the way we approached the comedic romance between Malicia and Keith in the midst of all the rat drama in this fairy tale world!"

"One of the reasons I'm such a huge Pratchett fan is because he tells stories in such an unusual way," concludes producer Andrew Baker. "He truly makes you look at the world differently. I believe that's why everyone we worked with is a genuine fan of *The Amazing Maurice* – both the film and the book. We hope filmgoers who discover *Maurice* for the first time will also fall in love with the characters and look at the world differently afterwards."

> "Fantasy is an exercise bicycle for the mind. It might not take you anywhere, but it tones up the muscles that can."
>
> TERRY PRATCHETT

BELOW Mood sketch by Heiko Hentschel, based on storyboard art by Jo Bub

OPPOSITE RIGHT Book of the movie cover by Gerlinde Godelmann

Acknowledgments

We would like to thank everyone who worked on *The Amazing Maurice*, and who made the film so special. Despite Covid lockdowns and remote working and having animators and production teams spread across Germany, around the UK, France and across the world, the production crew was very much a 'team' and we all felt part of something very special. The film is a collaboration of many talented individuals and we have been honored to work with you over the last two years of production.

A special mention and thanks go to our director, Toby Genkel, our co-director, Florian Westerman, and to Heiko Hentschel, who created most of the artwork for the film in his roles as production designer, character designer and art director. Also, the look and feel of *Mr Bunnsy* can be attributed to Heiko, who not only designed the characters and backgrounds but animated them as well!

A huge thanks to our partners on the film – especially Sky Cinema and Global Screen – and to Telepool, Deutscher Filmförderfonds, MOIN Film Fund Hamburg Schleswig-Holstein and FFA, The Creative European Media Programme of the European Union and to animation studios Studio Rakete in Hamburg and Red Star in Sheffield.

Our thanks and gratitude to the team at Narrativia, especially Rob Wilkins who, along with Rhianna Pratchett, has the role of guardian of the Terry Pratchett literary estate, and who worked with us to make sure the film honors the memory of the great author. A hearty thanks, too, to Suzy and Alex, assisting with every aspect of the guardianship. We have to say thanks also for the genius of Terry Pratchett, without whom we would not have our amazing cat, Maurice.

We would like to thank Ramin Zahed, Jo Boylett and the team at Titan Books, and especially Darren Chouings at Cantilever Media, who has herded all the cats, for creating this beautiful book and allowing us to share so much unseen artwork from the film.

Finally, we would like to honor the memory of our dear friend Jan Rogowski, Co-Founder and Line Producer at Red Star studios, who sadly passed away just as we were completing *The Amazing Maurice*. Jan was able to watch the film privately with his family before he passed away. As a life-long Terry Pratchett fan, Jan worked tirelessly to ensure the film lived up to both Pratchett's vision of Discworld® and his own deep affection for the source material. We could not have made the film without him.

GNU Terry Pratchett and Jan Rogowski.

Emely Christians
Andrew Baker
Robert Chandler

Author Acknowledgments

In the words of the amazing Terry Pratchett, "It's still magic even if you know how it's done!" I am so grateful to the gracious and talented teams behind *The Amazing Maurice* for being my generous behind-the-scenes guides on this entertaining project.

Thank you so much Andrew Baker (the wise wizard who knows all the magical secrets) for always being so kind to the fool who always had more questions. A big shout out to the very talented Emely Christians, Robert Chandler, Toby Genkel, Florian Westermann, Heiko Hentschel, Carter Goodrich, Terry Rossio, Peter Bohl, Andre Correia, Haris Ahmad, Sophie Vickers, Jerome Boutroux, Jared Embley, Faraz Hameed, Nico Rehberg, Felix Ferrand and Jordan Soler, and everyone else at Ulysses Filmproduktion, Cantilever Media, Studio Rakete, Red Star 3D, Narrativia, Sky Cinema, and Squeeze for being so generous with your time, patience and insights. Darren Chouings, thank you so much for all your assistance and for setting up all the Zoom chats and interviews so smoothly. I am also deeply grateful to Titan's Simon Ward and the talented designer Kerry Lewis.

Finally, I would like to thank my magnificent editor at Titan, Jo Boylett, who makes every project a delightful experience. (And to my sweet dog Gizmo: I know you'll forgive me for writing an entire book about a cat. You have to admit that he is pretty special!)

A SPECIAL THANKS TO OUR BRILLIANT TEAM THAT PUT THE *AMAZING* INTO THE AMAZING MAURICE

Adam Dolniak, Adam Lee, Ajay Arunan, Aleisha Baker, Aleksandra Muzyka, Alex Stott, Alice Deverchère, Alicia Sabot, Alina Bopele, Alvaro Martin, Alvin Arevalo Zamora, Amandine Bernard, Amina Muench, Andre Correia, Andrea Martin, Andrew Baker, Anne Miller, Anne Wendelin, Annselie Aberg, Antoni Kujawa, Ariyon Bakare, Armen Pamokdjian, Arran Hughes, Audrey Laureys, Aurea de las Casas Martin, Aurin Hitchens, Ava Rowan-Polley, Babette Kahn, Ben Smith, Bhushan R.Jagtap, Bondok Max, Calista Walker, Carrie Schilz, Carter Goodrich, Carys Rowan, Celesine Giraud, Celine Dunker, Chris Russell, Connor Woodey, Darren Chouings, David Cowles-Brooks, David Fernandez Giron, David Matthews, David Nuttall, David Tennant, David Thewlis, Davide Cioffi, Davide Pieropan, Debbie McWilliams, Denise Tie, Diana Suyerbayeva, Dil Bhakar, Duncan Western, Edwin Rhemrev, Elaine Gill, Eli Rowan-Polley, Elise Tewedros, Elizabeth Sankey, Elliot Renet, Emely Christians, Emilia Clarke, Fabio Messina, Faraz Hameed, Felix Ferrand, Felix Presch, Felix Schichl, Florian Westermann, Flossie Joseph, Franz von Auersperg, Friedolin Dreesen, Gabriella Kiszely, Gaelle Beerens, Gemma Arterton, Geoffrey Köhler, Gerardo Diez Blanco, Gerlinde Godelmann, Gerrit Wemmer, Giles New, Giuliana Bindi, Guillaume Glachant, Guy Iltis, Haris Ahmad, Harriet Ward, Harry Fast, Heidi Smith, Heiko Hentschel, Heiko Lueg, Himesh Patel, Hugh Bonneville, Hugh Laurie, Husam Al-Hakim, Ilektra Chrysanthou, Jack Moody, Jake Jackson, James Skilbeck, Jan Rogowski, Jana Bohl, Jane Harris, Janet Balmforth, Jared Embley, Jason Swanscott, Jemima McWilliams, Jerome Boutroux, Jesus Gutierrez Fernandez, Jim Johnson, Jo Bub, Joe Cochrane, Joe Sugg, John T. Coomey, Jordan Soler, Jose Miguel Cubillas Garcia, Julie Atherton, Julia Stuart, Justyna Schmidt, Katie Fieldman, Keiron Self, Kishan Barr, Konstantin Geisel, Leona Liberty, Lewis Grant, Lilian Robert, Lisa Baker, Lockie Giglia, Louis Paltnoi, Lucia Sancho Calzada, Luciano Maiwald, Lucy Kaulback, Lucy Paltnoi, Lynne Seymour, Maike Ramke-Lassahn, Maksims Aleksejevs, Malcolm Watts, Marc Harrison Lamb, Marcel Tie, Marcus Taylor, Mark Pitchford, Mark Walker, Martin Behem, Martin Rahmlow, Matt Baird, Matt Parry, Matthias Lappe, Matthias Parchettka, Megan Giglia, Melina Sputz, Mercedeh Jahanshahi, Michal Maletz, Michael Hülse, Michaela Zürcher, Mila Paltnoi, Mohamed Amine El Faqir, Moran Tennenbaum, Nico Rehberg, Niels Dervieux, Niklas Matthaei, Oliver Kurth, Owen Fern, Pantelis Vidalis, Paul Kidby, Paula Boram, Peter Bohl, Peter Serafinowicz, Philipp Wibisono, Rahul Venugopal, Ralph Christians, Ralph Homuth, Ralph Oliver Graef, Ramit Anchal, Remi Cauquil, Rob Brydon, Rob Wilkins, Robert Chandler, Roberta Walker, Rod Brown, Roddy McManus, Rosie Southward, Ruth Hunter, Sam Rhodes, Sam Webster, Samuel Rozier, Sara Leal, Sarah Riveli, Sarah Wright, Simon Isenberg, Simon Petrovitch, Sophie Rankin, Sophie Vickers, Sonja Matthes, Sreejith Thirunilath, Stefan Herrmann, Suzy Smithson, Szilard Hadobas, Tali Paltnoi, Terry Pratchett, Terry Rossio, Thibaut Vuillin, Thomas Yuri Coe, Thomas Wellendorf, Tim Liebe, Tim Nendza, Timo Ballin, Toby Genkel, Tom Howe, Tom Olieslagers, Tristan Lancey, Usman Olomu, Valentin Puig, Viola Lütten, Virginia Daniele, Wolfgang Christians, Yasamin Saadat

A Sky Original
Developed with the Support of
FFA
MOIN Film Fund Hamburg Schleswig-Holstein
The Creative Europe Media Programme of the European Union
In Association with Narrativia
In Collaboration with Global Screen and Telepool

Produced with the Support of
Studio Rakete
Red Star 3D
UK Film Tax Credit
Deutscher Filmförderfonds
MOIN Film Fund Hamburg Schleswig-Holstein
FFA
Moonshot Films
A Ulysses Filmproduktion Cantilever Media Production

www.amazingmauricefilm.com

BELOW Welcome to Bad Blintz poster art by Gerlinde Godelmann